GEORGIA O'KEEFFE

A Celebration of
Music and Dance

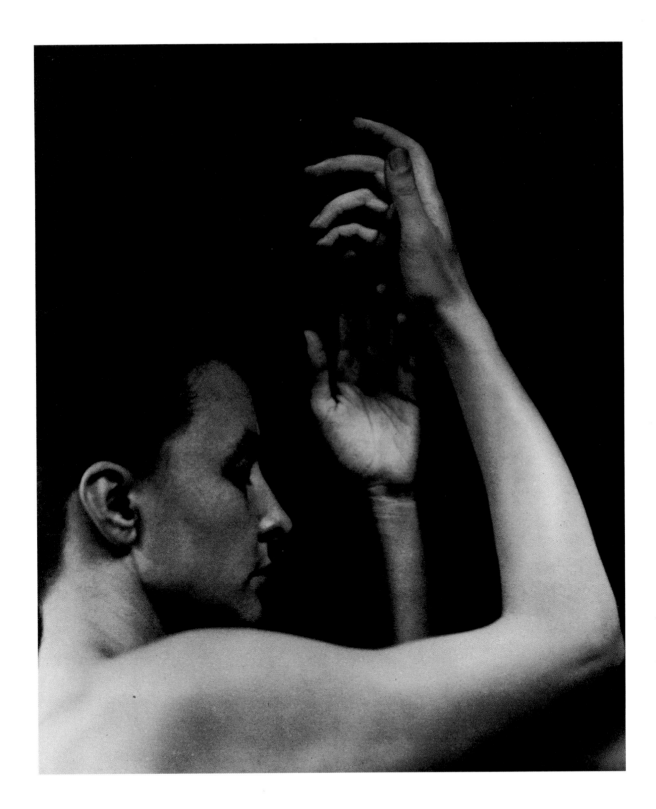

GEORGIA O'KEEFFE

A Celebration of
Music and Dance

Katherine Hoffman

GEORGE BRAZILLER, NEW YORK

First published in the United States in 1997 by George Braziller, Inc.

Text copyright © 1997 by Katherine Hoffman

See page 117 for photograph credits

Grateful acknowledgment is made to those listed below for permission to reprint the following material:

To Donald Gallup, The Georgia O'Keeffe Foundation, and The Yale Collection of American Literature, Beinecke Rare Book and Manuscript Library, Yale University, for several lines from Georgia O'Keeffe's June 1915, January 4, 1916, and January 14, 1916 letters to Anita Pollitzer.

To Simon & Schuster for four lines from W. B. Yeats's poem "Among School Children" from *The Collected Works of W. B. Yeats*, volume 1: *The Poems*, revised and edited by Richard J. Finneran. Copyright 1928 by Macmillan Publishing Company; copyright renewed © 1956 by Georgie Yeats.

To Harcourt Brace & Company for an excerpt from "Burnt Norton" in *Four Quartets*, copyright 1943 by T. S. Eliot and renewed 1971 by Esme Valerie Eliot.

For information, please address the publisher:

George Braziller, Inc., 171 Madison Avenue, New York, NY 10016

Library of Congress Cataloging-in-Publication Data:

Hoffman, Katherine, 1947–
 Georgia O'Keeffe : a celebration of music and dance /
Katherine Hoffman.
 p. cm.
 Includes bibliographical references.
 ISBN 0-8076-1427-0 (hardcover)
 1. O'Keeffe, Georgia, 1887–1986—Criticism and
interpretation. 2. Music in art. 3. Dance in art. I. Title.
ND237.05H64 1997
759.13—dc21 97–27612
 CIP

Frontispiece illustration: Alfred Stieglitz, *Georgia O'Keeffe*, 1920. The Metropolitan Museum of Art, New York (28.127.2), gift of David A. Schulte, 1928. See fig. 12.

Designed by Philip Grushkin

Printed and bound by G. Canale & C., Italy

First edition

To my children,
Kristen, Geoffrey, and Ashley,
and my husband, Graham,
with love

Acknowledgments

Rather than a long list of names, I would like to thank the very helpful librarians and curators of the various libraries, museums, and galleries, as well as the private collectors, connected with this project. In particular, I thank the interlibrary loan librarians at Saint Anselm College; Marianne Lake who typed the manuscript; and Barbara Buhler Lynes, who provided assistance in locating some of the works. This book would not have come into being without the vision of George Braziller, who urged me to put together a proposal from a brief telephone conversation; and the careful work of his assistant, Mary Taveras, who handled many of the details of procuring illustrations and other editorial tasks.

Thank you to my husband, Graham Ward, for his support and encouragement. And thank you to my three children, Kristen, Geoffrey, and Ashley, for being who you are, each with your own musical and artistic talent, as well as dancing spirit, which is exemplary and admirable. You have each understood in your own way the power and lure of O'Keeffe's work, which I appreciate.

And finally, to Georgia O'Keeffe, an accolade, for the creation of a body of work that has inspired and moved me for more than twenty years and that remains spirited and strong.

Contents

Preface

Approximately twenty years ago, when I was young doctoral student, one of my instructors suggested that I look at the work of Georgia O'Keeffe. I did, and I was "hooked," drawn to her work and all its magnificent shapes and colors, which evoked another language that had its own rhythms, harmonies, and melodies. My interest led to a doctoral dissertation and the publication of a book, *An Enduring Spirit: The Art of Georgia O'Keeffe* in 1984. In the years since I began my research, the study of Georgia O'Keeffe has become a small industry, and she, for some, has become a kind of cult figure, an enigma of the New Mexican desert. Much of the literature on O'Keeffe and her work has focused primarily on sexual symbolism or on specific thematic imagery, such as the flowers, the bones, and the city scenes. But little has been written about the music and dance elements inherent in a number of her works. This book seeks to further the discussion concerning the power of music and dance in O'Keeffe's work. O'Keeffe has been dead for over a decade now. Therefore, it seems appropriate that new discussions and compilations of her work be published.

The following pages describe the milieu in which O'Keeffe worked, as well as the work itself. The early twentieth century was rich with experimentation in all the arts, influencing O'Keeffe directly and indirectly, and providing her with an opportunity to develop her own unique language that contained some basic elements from the worlds of music and dance.

Because of the large amount of biographical literature on the artist, this book will concentrate on those aspects of O'Keeffe's life, work, and cultural milieu that provide a foundation for understanding the significance of the music and dance elements in her work. Beginning with her early watercolors, such elements can be traced through selected works throughout O'Keeffe's career to her late watercolors and sculpture. Specific motifs, such as the spiral, are repeated and refined, like the theme and variations of a music or dance piece. Come then to look deeply, for O'Keeffe's paintings, drawings, and sculpture carry with them a celebration of music, dance, and the beauty of visual forms.

And lo the sea, that fleets about the land
And like a girdle clips her solid waist,
Music and measure both doth understand;
For his great chrystal eye is always east
Up to the moon and on her fixed fast.
And as she danceth in her pallid sphere
So danceth he about his centre here.

<div align="center">

SIR JOHN DAVIES
"Orchestra," 1596

</div>

They cut me down and I leap up high
I am the life that'll never, never die;
I'll live in you if you'll live in me—
I am the Lord of the Dance, said he.
Dance then wherever you may be . . .

<div align="center">

SYDNEY CARTER
"Lord of the Dance"
(Adapted from a Shaker Melody)

</div>

. . . of all things earthly it is only in music that one finds any analogy to the emotional content of these drawings, to the gigantic swirling rhythms and the exquisite tenderness so powerfully and sensitively rendered—and music is the condition toward which according to Pater, all art constantly aspires. Well, plastic art in the hands of O'Keeffe seems now to have approximated that.[1]

WILLIAM MURRELL FISHER, 1917

What distinguishes Miss O'Keeffe is the fact that she has discovered a beautiful language with unsuspected melodies and rhythms. . . .[2]

LEWIS MUMFORD, 1927

Singing has always seemed to me the most perfect means of expression. It is so spontaneous. And after singing, I think the violin. Since I cannot sing, I paint.[3]

GEORGIA O'KEEFFE, 1922

The sun gleamed brightly that clear autumn day more than one hundred years ago. It was November 15, 1887. In New York, the Roeblings' daring Brooklyn Bridge was recently completed. In Paris, the grand and dramatic Opera designed by Charles Garnier had been open for twelve years, and the work on the inspiring Eiffel Tower had begun. In Chicago, William Le Barron Jenney had just completed his Home Insurance Company Building, the first completely metal-framed building and monument for the development of the modern skyscraper. It was a world of growing industrialization, urbanization, and technology.

On that day in the small town of Sun Prairie, Wisconsin, Georgia Totto O'Keeffe was born in the farmhouse of Ida and Francis O'Keeffe. She became the second of seven children. The world of Sun Prairie belonged to the eighteenth and nineteenth centuries, where the patterns and rhythms of Midwestern farm life and the land dominated the region. The rhythms of this landscape and subsequent landscapes—in Lake George, Texas, New Mexico—would have an important influence on O'Keeffe.

In the same year, a young twenty-seven-year-old painter, Stacy Tolman, completed a painting, *The Musicale* (1887), which seemed to symbolize the growing importance of the interrelationship of music, dance, and the visual arts. Here, music, dance, and the visual arts appear to have come together in the social space of the artist's studio. As was frequently the case in late-nineteenth-century America, formal musicals, dance performances, and solo or impromptu sessions were held in artists' studios. Tolman, a painter, a teacher, and amateur musician, gives us portraits of three of his friends, each playing an instrument. Signs of the visual artist's presence are evident as well—the bundled portfolios, images on the wall, and the props for painting, such as draperies and a parasol. Together, the musical and artistic allusions point to the power of creativity, inspiration, feeling, and insight shared by music, dance, and art.

Nineteenth-century American art included a number of works that emphasized the power of music and dance, such as William Sidney Mount's *Rustic Dance After the Sleigh Ride* (1830) and *The Power of Music* (1847), Eastman Johnson's *Fiddling His Way* (1866) and *The Voice of the Harp* (1872), Thomas Eakins's *Elizabeth at the Piano* (1875), Arthur Davies's *Romance* (1880), and J. Alden Weir's *Idle Hours* (1888). O'Keeffe's evocation of musical and dance forms is therefore part of a continuum of explorations of musical forms in the visual arts.

By the late nineteenth century and into the early twentieth century in both Europe and America, the search for "the beautiful," in abstract rather than physical terms, was a goal for fin de siècle aesthetic searchers. As Luna May Ennis wrote in *Music in Art* in 1904, "whether the medium of expression be canvas or marble, poetry or sound, both represent the beautiful, the one making its appeal through the eye, the other through the ear to the heart."[4] Added to this search was the search for "inner" meaning and expression thereof that evolved through the writings of Wassily Kandinsky and others. For Kandinsky, "Both arts [dance and painting] must learn from music that every harmony and every discord which springs from the inner spirit is beautiful, but that it is essential that they should spring from the inner spirit and from that alone."[5]

Although O'Keeffe wasn't always directly involved with experiments or theories in the arts, it is useful to examine the cultural context in which she lived and worked, for significant cultural threads were, consciously or unconsciously, woven into the fabric of her work. As Dore Ashton has written, "No matter how banal the thought that the artist is a man of his time, the fact is that the history of art and literature is filled with statements, more or less eloquent, affirming the artist's sense of being shaped by the epoch in which he performs his art. In some cases, he is not so much shaped, as prodded . . . the 'time' of an artist makes itself felt. . . ."[6] Let us examine some of the cultural forces, particular figures, and events that influ-

enced O'Keeffe's development or served as catalyst for the development of her unique visual vocabulary, which came to include elements of music and dance.

The Romantic and Symbolist movements of the nineteenth century lay the foundations for the context of O'Keeffe's work. In music, the Romantic tradition spawned the moving works of Ludwig van Beethoven, Frédéric Chopin, Robert Schumann, Franz Liszt, and Richard Wagner. The powerful last movement of Beethoven's Ninth Symphony includes a chorus, asking through Johann Christoph Friedrich von Schiller's "Ode to Joy": "O, you millions embrace/this kiss of the whole world!/. . . O World do you sense the Creator?/Seek him above the tent of the stars!/Above the stars must he dwell."[7] Wagner called for a *Gesamtkunstwerk*, the Total Work of Art, which would unite poetic drama, music, the visual arts, and dance. In the visual arts, the Romantics emphasized emotion and the power of nature. For many, the landscape was a type of sacred text that revealed truth, the sublime, and the awesome, while the artist was a type of priest who interpreted and revealed nature to society.

This connection between creation, revelation, and the arts can be traced back further to the Greek philosophers, some of whom saw creation as an act of music. By the Middle Ages there was the further notion that the created universe was in a state of music, that there was a perpetual cosmic dance. One early medieval encyclopedist, Isidore of Seville, wrote, "Nothing exists without music; for the universe itself is said to have been framed by a kind of harmony of sounds and the heaven itself revolves under the tones of that harmony."[8] The concept of movement in the universe as a dance is seen further in the sixteenth-century poem "Orchestra." By the seventeenth century René Descartes recognized that the movement of music could inspire movement in the soul and that poetics "like our music was invented to excite the movements of the soul."[9]

The power of music figured prominently in the Symbolist aesthetic. For the Symbolist artist, the work of art was the consequence of emotion and the inner spirit of the artist, not of the artist's observation of nature or other aspects of visible reality. Nature could serve as the inspiration for an artistic "idea," but the greatest and highest reality laid in the realm of imagination and fantasy. The Symbolists favored the world of dreams, of suggestion, of mystery, and of metamorphosis—not of exact description. Some, such as Odilon Redon, were attracted to Eastern religions that promoted the idea of a fusion between humankind and nature. Representations of silence, solitude, and isolation were also ways of withdrawing from the material world and penetrating a deeper spiritual world. The opposite of silence as a means of reaching the spiritual was the Dionysian ecstasy of the dance, as seen in images of Salomé or the dancer Loïe Fuller, who had excited many European audiences with her flowing scarves and the exotic lighting effects of her performances.

Leading the Symbolist movement in poetry and literature were the 1873 reissue of

Charles Baudelaire's *Fleurs du Mal*, the 1876 publication of Stéphane Mallarmé's *Après-Midi d'un faune* (later the title of a Ballets Russes production), Mallarmé's *Poésies* (1887), and Maurice Maeterlinck's plays. Maeterlinck's notion of correspondences among color, sound, and emotional state later greatly interested O'Keeffe.

Philosophical grounding for the Symbolists lay in Neoplatonism as well as in the theories of Arthur Schopenhauer, Friedrich Nietzsche, Emanuel Swedenborg, Friedrich Schelling, and Henri Bergson. Schopenhauer, for instance, viewed the world pessimistically as "will and representation," where reality is will and the world, man's representation through will. There were as many different worlds as thinkers.

The French philosopher Henri Bergson in his *Creative Evolution* began to tamper with traditional notions of time. Before and after were not important; rather time was a continuum and there were no definite fixed objects in time. According to Bergson, ever-changing aspects of our life made each moment different. This concept of time was later illustrated in artistic images of simultaneity and dynamism (as in Cubism, Futurism, and their offshoots), as well as in visual pieces with reference to music, an art of time, versus painting, an art of and in space. Bergson's *élan vital*, or life force, and his exaltation of the intuitive and instinctive over the rational, provided a sense of freedom for post-Victorian artists and intellectuals, in particular the Alfred Stieglitz circle. Bergson's theories became popular on both sides of the Atlantic. The photographer Edward Steichen, who was a friend of Stieglitz's, greatly admired both Bergson and Maeterlinck. Mabel Dodge (later Mabel Dodge Luhan), influential through her salons and in drawing O'Keeffe to New Mexico, translated Bergson's concept of the *élan vital* to the power of sexuality. Dodge became friends with both Stieglitz and O'Keeffe and was a catalyst in bringing together a variety of vibrant and interesting people.

Nietzsche frequently made reference to music and dance. In *The Birth of Tragedy* (1872), Nietzsche suggested that music, more so than the visual image, is capable of symbolizing the natural order. Indeed music, particularly that associated with Dionysian festivals, serves to present wisdom by revealing the very heart and soul of nature and human passions. Although God may be dead for Nietzsche, art is seen as wiser or more philosophical than philosophy, and music is wiser or more philosophical than language. A "Socrates who practices music" is envisioned, as well as an art based in part on Wagnerian concepts that would reveal the human condition.

In other works, Nietzsche made direct reference to dance and saw the art of life as a dance in which the dancer rises to inner freedom and to a rhythmic harmony that surpasses the ordinariness of everyday existence. Nietzsche projected the dance and God outside man. His famous lines from *Thus Spake Zarathustra* (1883–91) have reverberated through the years: "I would believe only in a god who could dance . . . when I saw my devil I found him

serious . . . it was the spirit of gravity. . . . Now I am light, now I fly, now I see myself beneath myself, now a god dances through me."[10] Although Nietzsche died in 1900, his vision of "dance" as a liberator of humankind had an impact into the twentieth century.

O'Keeffe read and greatly admired Nietzsche. Indeed, in Canyon, Texas, O'Keeffe reported in letters to the photographers Paul Strand and Alfred Stieglitz that she had confronted a Texas Baptist minister who had attacked the philosopher as being an intellectual catalyst for World War I. An incensed O'Keeffe informed the preacher that he did not understand Nietzsche's philosophy nor could he have possibly ever really read Nietzsche.

An important part of Symbolist thinking was the theory of correspondences based in large part on the writings of Baudelaire. Baudelaire viewed all things as symbols or potential symbols of a transcendent reality, to which the artist has privileged access. Correspondences operated on two levels: between different arts—painting, poetry, and music—and within the same art, where color or sound suggested ideas in another art by analogy. In essence, the Symbolists hoped for a synthesis of all the arts, a correspondence between forms and sensations. Music, in particular, was identified with inspiration and stimulation of the imagination. (Many of the Symbolists were admirers of Wagner.) Pictorial composition was frequently described in terms of musicality, which was considered an important manner of expressing beauty. The emotional quality of a work of art was communicated through its poetic qualities, musicality, and visual content. In general, the Symbolist work frequently stressed a flattening of represented space, the use of rhythmic lines, frontalization of an image, and suppression of details.

The Symbolists' exploration of a dream state as a way to penetrate the spiritual was clearly influenced by Sigmund Freud, who had begun his studies of dreams and the unconscious by the 1880s. His *Interpretation of Dreams* (1900), with its emphasis on the unconscious and the dream world, had a great impact on both Europeans and Americans. The physicist and philosopher Ernst Mach, a contemporary of Freud's, emphasized the significance of colors, shapes, and sounds for concepts of transformation and the formulation of a sense of identity and of the ego:

> *When I say the Ego cannot be saved, I mean that it resides in man's perception of everything and every event, that this Ego is a part of everything we feel, hear, see, and touch. Everything is ephemeral, a world without substance that consists only of colors, shapes, and sounds. Reality is in perpetual movement, it is changing reflections. What we call the Ego is crystallized in this interplay of phenomena. From the instant of our birth to our death, it is in a permanent state of transformation.*[11]

Indeed for many of the Symbolists, such as Mallarmé, art was the expression of the mystery of human existence. And for Mallarmé, the art of the future was the Dance, as it alone

could translate the transient, fleeting, or abrupt element of human existence to the "Idea," or higher reality. The movements or gestures of the dancer were seen as a visual incorporation of the Idea.[12] Mallarmé's aesthetic views were also set forth in an essay, "Music and Literature," published in *La Revue blanche* in October 1894. Some of his comments in that essay are very similar to Stieglitz's ideas and to the ideas of some of the artists in his own circle about photography and art:

> *Using the most elemental and elementary of means, he will try (for example) the symphonic equation of the seasons of the year, the habits of a sunbeam or a cloud. He will make one or two observations analogous to the undulant heat or other inclemencies of the changing climate, which are the multiple sources of our passions . . . nature exists; she will not be changed. . . .* [13]

Was O'Keeffe a Symbolist? Certainly her expressive early abstractions reflect elements of Symbolism in style and content, although she was not involved deeply in theories. Indeed, a 1915 pastel drawing entitled *Symbolist Composition* by Theo van Doesburg, with its abstract arched wave forms rising in shades of purple, gray, orange, and red, subtly blended into one another, much resembles O'Keeffe's use of rising wave forms in a number of early works, such as her *Light Coming on the Plains III* (1917) or her *From the Plains I* (1919).

O'Keeffe's European-educated teachers at the Art Institute of Chicago, as well as her teacher Arthur Wesley Dow, who had studied with Paul Gauguin, had clear knowledge of the Symbolist aesthetic. Dow's teachings at Columbia University's Teachers College in 1914 and the spring of 1916 had a large impact on O'Keeffe. His well-known text, *Composition* (1912), contained a more decorative and abstract approach, more open to interpretation than the strict academic exercises of her earlier training at the Art Students League. Dow was also influenced by his mentor, Ernest Fenellosa, curator of the Japanese Department at the Museum of Fine Arts in Boston. Like Fenellosa, Dow felt that music was a key to the other arts and that the spatial arts might be called visual music. Dow wrote in his introduction to *Composition*, "[Fenellosa] believed music to be in a sense, the key to the other arts, since its essence is pure beauty. . . . Space art may be called 'visual music' and may be studied and criticized from this point of view."[14] Dow's emphasis on harmonious, spaced linear design rather than realistic imitation, on abstract arrangements of light and dark patterns instead of chiaroscuro effects, and on color harmonies, influenced O'Keeffe greatly as she sought, through much of her career, to fill a space in as beautiful a way as Dow had advocated. Dow also believed in the power of spiritualism and was devoted to the living spirit that was for him the domain of art.

Stieglitz, photographer, advocate for modern art through his galleries, and the first to

show O'Keeffe's work in New York, was also influenced by the aesthetics of the Symbolists. In particular, Stieglitz was interested in the correspondence between the visual arts and music and in the personal expressive qualities of line, shape, and color. His own series of photographs, Music: A Sequence of Ten Cloud Photographs, Songs of the Sky, and Equivalents, a series of cloud images, are clearly rooted in Symbolist thought. Through these photographs Stieglitz hoped to carry out the idea that abstract shapes or colors could express personal feelings, thoughts, and sensations (fig. 1). Stieglitz wrote of the photographs, "My photographs are a picture of the chaos in the world and of my relationship to that chaos. My prints show the world's constant upsetting of man's equilibrium and his eternal battle to re-establish it."[15]

Figure 1. Alfred Stieglitz, *Music: A Sequence of Ten Cloud Photographs, No. 1*, 1922. Gelatin silver print, 7 1/2 x 9 3/8 in. Museum of Fine Arts, Boston, Alfred Stieglitz Collection (24.1732), gift of Alfred Stieglitz.

To the writer Hart Crane, Stieglitz communicated his enthusiasm about the new work and its relation to music: "[I]t was great excitement—daily for weeks . . . I had told Miss O'Keeffe I wanted a series of photographs which when seen by Ernest Bloch (the great composer) he would exclaim: Music! Music, Man, why that is music! . . . and Bloch saw them—what I said I wanted to happen happened verbatim."[16]

As her correspondence from Columbia, South Carolina, with her friend Anita Pollitzer reveals, O'Keeffe read many books recommended by Stieglitz. (O'Keeffe would marry Stieglitz in 1924.) Among these was the writing of Rémy de Gourmont, a spokesman for the Symbolist movement in America. In response to the question, "Can a photograph have the significance of art?" written for *Manuscripts* (no. 4, December 1922), O'Keeffe indicated agreement with Gourmont's writing.

Also steeped in Symbolist literature was Paul Rosenfeld, a music and art critic who became a primary interpreter of the artists in the Stieglitz circle during the late 1910s and early 1920s. Rosenfeld and a number of other critics, such as William Murrell Fisher and Lewis Mumford, as well as artists, quickly saw and experienced music in O'Keeffe's work. Rosenfeld wrote:

> *The most complexly varied contraries of tone are juxtaposed with a breathtaking freshness. Chords of complementary colors are made to abut their flames directly upon one another, filling with delicate and forceful thrust and counter thrust the spaces of her canvases. Through this Virginian, the polyharmonies of the compositions of Stravinsky or Leo Ornstein seem to have begotten sisters in the sister art of painting. . . .*
>
> *Her work exhibits passage upon passage comparable to nothing more justly than to the powerfully resistant planes of close intricate harmony characteristic of modern music. She appears to have a power like the composers, of creating deft, subtle, intricate chords and of concentrating two such complexes with all the oppositional power of two single complementary colors. And the modern music is no more removed from both the polyphony of the madrigalists and the predominantly homophonic effects of the romantic composers, than this painting from both the ruggedly but simply interplaying areas of the renaissance, and the close, gentle, melting harmonies of the impressionists.*[17]

Herbert Seligmann, Stieglitz's young assistant for a number of years, wrote in 1923, ". . . and sometimes rockets of color soar, dark planes, ribbons of flaming gold pass and are built in musical harmony . . . she has made music in color issuing from the finest bodily tremor in which sound and music are limited."[18] That same year Seligmann also wrote:

A number of her paintings are so closely associated with musical experience, that it seems most natural to name one of them "Music." Quite literally, some of them are rendering the effects of musical composition, which is more often visualized as a sort of architecture; Miss O'Keeffe is one of the few to have rendered its equivalent in painting with complete conviction of reality.[19]

The critics' praise, in its own poetic and musical language, served to enhance and emphasize O'Keeffe's own musical and gestural language.

In addition to the Symbolist aesthetic, a number of other sources alluded to ties between the musical and the visual. Alon Bement, O'Keeffe's teacher and mentor at the University of Virginia, recommended two books to the young artist, Wassily Kandinsky's *Concerning the Spiritual in Art*, translated into English in 1914, and *Cubists and Post-Impressionism*, a 1914 volume by the Chicago lawyer and collector Arthur Jerome Eddy. Kandinsky influenced Stieglitz and his circle, as well as a number of European artists; Stieglitz even published a portion of Kandinsky's writings in *Camera Work* (no. 39), in 1912. Kandinsky's emphasis on the role of expression, of an "inner necessity," was noted in the issue, which also cited Paul Cézanne, Henri Matisse, and Pablo Picasso, as seekers of an inner spirit. A 1915 O'Keeffe letter to Anita Pollitzer indicates O'Keeffe was already in her second reading of Kandinsky.

Of particular interest to O'Keeffe were Kandinsky's ideas of color harmony and his connections between music and the visual arts. For instance, Kandinsky wrote, "Color is the key board, the eyes are the harmonies, the soul is the piano with many strings. . . . Musical sound acts directly on the soul and finds an echo there since music is innate in man."[20] O'Keeffe, Stieglitz, and the artists of Stieglitz's circle were attracted to Kandinsky's pursuit of inner meanings that were to be found in the life of colors. Kandinsky found in music "the most non-material of the arts," a key to rhythmic and abstract construction (fig. 2). He cited the composer and painter Arnold Schoenberg as providing an appreciation of abstraction, and the dancer Isadora Duncan for helping him learn the importance of primitive abstraction and movement. Further, Kandinsky noted the experimental works in color and sound by Aleksandr Scriabin and the systematic themes music teachers in St. Petersburg used to teach color and music.

In his writing, Kandinsky emphasized the significance of the color blue:

The power of profound meaning is found in blue, and first in its physical movements (1) of retreat from the spectator, (2) of turning in upon its own centre, the inclination of blue to depth is so strong that its inner appeal is stronger when its shade is deeper. . . .

Blue is the typical heavenly color. The ultimate feeling it creates is one of rest. When it sinks almost to black, it echoes a grief that is hardly human. When it rises toward

Figure 2. Wassily Kandinsky, *The Garden of Love (Improvisation Number 27)*, 1912. Oil on canvas, 47 ³/₈ x 55 ¹/₄ in. The Metropolitan Museum of Art, New York, Alfred Stieglitz Collection (49.70.1), 1949.

white, a movement little suited to it, its appeal to men grows weaker and more distant. In music a light blue is like a flute; a darker blue a cello; a still darker blue a thunderous double bass; and the darkest blue of all—an organ.[21]

It seems to be no coincidence that a number of O'Keeffe's early works, such as *Blue Nos. 1–4* (pls. 1–4), as well as *Music–Pink and Blue Nos. 1* and *2* (pls. 5 and 6) along with later works, such as her Pelvis paintings or her late watercolors of the 1970s, emphasize the color blue.

Eddy's book, besides providing O'Keeffe with exposure to artists such as Matisse, Picas-

so, Cézanne, James Abbot McNeill Whistler, Arthur Dove, and the Futurists, also refers in particular to Whistler's musical references, his nocturnes, symphonies, and harmonies.[22] Furthermore, an entire chapter was devoted to "Color Music." An appendix contains a list of exhibits at Stieglitz's 291 gallery from 1906 to 1913. These exhibits included artists Pamela Colman Smith and Max Weber, both students of Arthur Dow and both of whom had dealt with musical imagery. Smith's work, shown in 1907 in the first exhibition not devoted to photography, included images that bear some affinity to O'Keeffe's work, e.g., the plumelike forms in Smith's *Chromatic Fantasy–Bach* (1907) resemble the flowing forms in O'Keeffe's *Blue Nos. 1–4* (see pls. 1–4), while Smith's *Beethoven Sonata No. 2* (1907), with its evocation of Beethoven in a flowing cape, reminds one of Stieglitz's photographs of O'Keeffe in a cape, or of O'Keeffe's *Lake George, Coat and Red* (1919).

Eddy also refers to the experiments of the Ballets Russes and the controversy it had inspired. He ends his book by stating, "the Cubists and the Futurists and the color musicians . . . help us to understand by purely human experience how it is that there may be some things which even humans cannot understand—but which are."[23]

Attracted to the vibrancy of various artists and writers experimenting with new forms and content, O'Keeffe, after her two initial stays in New York in 1908 and 1914 as a student at the Art Students League, and then at Columbia University, read as much as she could about innovations in the arts. She read issues of *Camera Work*, Steiglitz's "baby," which covered all the arts and experiments in modernism; and issues of *The Masses*, the leftist political and artistic journal that featured the writing of figures such as Max Eastman, John Reed, Sherwood Anderson, and Mabel Dodge. At the recommendation of Arthur Whittier Macmahon, a young instructor of political science at Columbia University who had met O'Keeffe while they were both teaching summer school in 1915, O'Keeffe read Randolph Bourne's *Youth and Life* (1913) and Floyd Dell's *Women as World Builders* (1913). Macmahon shared Bourne's antiwar beliefs as well as his concern for individual self-fulfillment through group movements such as feminism and trade unionism.

Women as World Builders included a study of a variety of independent women involved in politics and the arts, including Charlotte Gilman, Jane Addams, Emma Goldman, and Isadora Duncan. Of particular significance was O'Keeffe's exposure to the art of the dancer Isadora Duncan. Dell emphasizes the harmony of the body and soul as embodied in Duncan's work. Quoting Duncan, Dell noted,

> *"The dancer of the future will be one whose body and soul have grown so harmoniously together that the natural language of that soul will have become the movement of the body. The dancer will not belong to a nation but to all humanity. She will dance, not in the form of nymph nor fairy, nor coquette, but in the form of a*

woman in its greatest and purest expression . . . she will dance the changing life of nature, showing how each part is transformed into the other . . . she will help womankind to a new knowledge of the possible strength and beauty of their bodies, and the relation of their bodies to the earth nature and to the children of the future."[24]

This emphasis on the freedom and expression of the body and its relationship to nature appeared in O'Keeffe's Nude Series (pls. 7–19) and in her paintings where the human form is evoked through nature, such as the series *Pink and Green Mountains Nos. 1–5* (pls. 20 and 21). In the latter series, the human form is linked with mountain imagery in sensuous watercolor washes.

In 1917, O'Keeffe wrote to Anita Pollitzer from Texas that she had been reading several volumes for a talk on aesthetics—Willard Huntington Wright's *The Creative Will* (1916), Clive Bell's *Art* (1914), Marius de Zayas's *African Negro Art: Its Influences on Modern Art* (1916), and Eddy's *Cubists and Post-Impressionism* (1914). Wright referred to analogies between the arts, stating, "There is no abstract quality of a rhythmic nature in any one art which does not have an analogy in the other arts. Because music was the first art to become abstract, we have an aesthetic musical nomenclature; and generally it is necessary to use musical terms in describing corresponding qualities in literature, drawing, painting and sculpture."[25] Although Wright did not consider dance to be, as music was, in the realm of great art, he did note its importance for the development of physical grace and harmonious body proportions and emphasized the connections between art and the human body. "The deeper facts of art and the deeper facts of life (two being synonymous) can be tested by the forces, construction, poise, plasticity, forms and mechanism of all life; and art, in all of its manifestations, is, in its final analysis, an interpretation of the laws of bodily rhythm and movement."[26]

Although de Zayas's writing would be considered racist in many ways in 1990s terms, he does point to African art's influence on modern art, and for him the significance of the feeling, sensation, and abstract form that he saw inherent in African art. He wrote, "It is certain that before the introduction of the plastic principles of Negro art, abstract representations did not exist among Europeans. Negro art has reawakened in us the feeling for abstract form, it has brought into our art the means to express our purely sensorial feelings in regard to form, or to find new form in our ideas."[27] Among the illustrations in the book is a carved wooden vase from the Congo (Kasai district). The gentle, undulating wave forms on the vase are quite similar to some of the wave forms in O'Keeffe's work, such as her *Blue and Green Music* (pl. 22), *Abstraction, Alexis* (1928), and *Wave, Night* (1928).

Besides her reading, O'Keeffe's own experiences and exposure to various figures, events, and artworks may be seen to have contributed to the developments and evolution of the music

and dance "vocabulary" in her work. O'Keeffe herself loved to dance. In her first years in New York when she came to the Art Students League to study, she was a favorite of many of the young men. She went out frequently to dance, and she went to a costume ball as Peter Pan. But she realized there were to be consequences to her dancing, that the young men also wanted her to pose for their paintings, and she would not have enough time to paint. She soon realized she wanted to be the creator. Many years later she observed, "I first learned to say no when I stopped dancing. I liked to dance very much, but if I danced all night, I couldn't paint for three days."[28]

On January 2, 1908, the day after Stieglitz's forty-fourth birthday, O'Keeffe and some of her fellow students went to Stieglitz's gallery 291 to see the Rodin drawings on display there. At age twenty, O'Keeffe was exposed for the first time to Stieglitz, to 291, but something about the spirit of 291 and its dedication to modern art attracted her. She returned again in March to see an exhibit of works on paper by Matisse. In *Camera Work* (no. 25), the critic Charles Caffin compared Matisse with Isadora Duncan in an essay entitled "Henri Matisse and Isadora Duncan," citing the importance of the expression of a primitive, elemental feeling by both artists. In a 1913 special issue of *Camera Work*, Stieglitz included a reproduction of one of Matisse's nude charcoal drawings. Although the drawing is not a watercolor, its seated, relaxed pose and fluidity of line can be seen to have an affinity with O'Keeffe's nudes (see pls. 7–19).

Rodin's free-flowing organic drawings were quite different from the more academic drawings and paintings O'Keeffe had been exposed to at the Art Students League. They must have spoken deeply to her, however, for her series of nude watercolors, begun in 1916, clearly reflect the fluency and freedom of Rodin's work. Although the Rodin drawings O'Keeffe saw were not all necessarily of dancers, Rodin had done a number of drawings of dancers, and much of his visual vocabulary may be rooted in the gestures of dance.

Rodin, like many artists of his time, was fascinated by the dance. He had sketched Loïe Fuller, Isadora Duncan, the French cancan, and Royal Cambodian dancers. Many of his sculptures, with their emphasis on movement, may also have roots in dance, expressing inner feelings by the mobility of the muscles. For Rodin, the gesturing body was more than physical and individual and seemed to express the larger Symbolist view that the dance was the "Idea" made visible. In Mallarmé's words, as previously noted, "The dancer is not a woman who dances, . . . but a metaphor . . . [and] suggests by prodigies of bending and of leaping, by a corporeal writing, what would require paragraphs of prose, both dialogue and description, to express in words; a poem freed from all the machinery of the writer."[29] In Rodin's drawings and sculptures, the figure is freed from convention and dances to its own expressive rhythms. So, too, do O'Keeffe's nudes. One of Rodin's drawings of Isadora Duncan in a seated position,

Figure 3. Auguste Rodin, *Drawing*. Date, medium, and dimensions are unknown. Reproduced from a colored collotype, 11 1/2 x 7 15/16 in., that appeared in *Camera Work* no. 34/35 (April/July 1911), plate 4. Philadelphia Museum of Art ('66-205-34 [8]), gift of Carl Zigrosser.

as well as another drawing of a kneeling nude figure (fig. 3) with ballet slippers sketched below the figure (the latter appeared in a special issue of *Camera Work* in 1911), show a clear connection to some of O'Keeffe's nudes. In the Isadora Duncan drawing, the dancer although seated, is depicted close to the viewer with flowing lines in a conventional, part-frontal, part-profile pose. As in O'Keeffe's nudes, the figure emphasizes the rhythmic flow of lines and shapes of the human form. In the *Camera Work* drawing, the representation of the body has been simplified further, emphasizing the spare grace found in the simple act of kneeling. And O'Keeffe, as Rodin, captured the rhythm and grace inherent in the human body.

Matisse also dealt with the moving and dancing figure as well as with vibrant color, both

of which attracted O'Keeffe. Besides the works on paper at 291, O'Keeffe would also have seen Matisse's *Dance I* (fig. 4) in Eddy's *Cubists and Post-Impressionism*. Matisse's large-scale nude dancers exude vibrancy and rhythmic freedom, celebrating the joy of movement as they circle around the canvas in a field of sumptuous blue and green. Matisse composed a second version, *Dance II* (1909–10), where the cavorting dancers exude a more primal energy. And in Matisse's *Music* (1909–10), one finds five simplified nude figures making music with a violin, pipes, and song.

Matisse continued his interest in music and dance throughout his career, associating dance with life, rhythm, and a kind of significant primitive power and energy. Notable is his large-scale dance mural for the Barnes Foundation in Merion, Pennsylvania in 1931–33, resulting in two versions, the Paris Dance Mural and the Merion Dance Mural. O'Keeffe would have undoubtedly heard about the process of doing the murals. One finds undertones of Mallarmé in Matisse, too, and it seems significant that Matisse was working on the Barnes com-

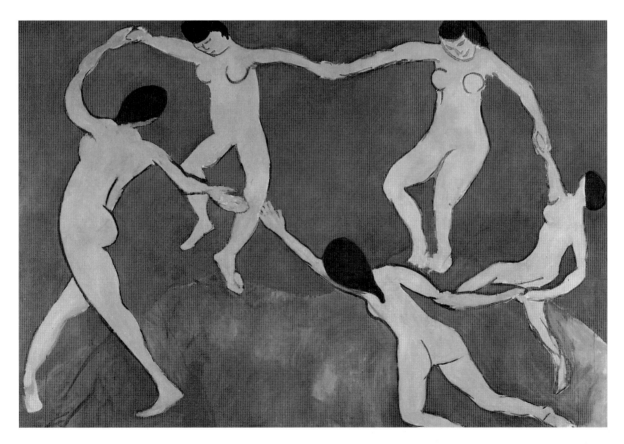

Figure 4. Henri Matisse, *Dance I*, 1909. Oil on canvas, 8 ft. 6 ½ in. x 12 ft. 9 ½ in.
The Museum of Modern Art, New York, gift of Nelson A. Rockefeller in honor of Alfred H. Barr, Jr.

mission while he was also working on his illustrations for Mallarmé's *Poésies*. In the late 1940s, Matisse created his well-known cutouts for his book *Jazz*, which through color and form evokes the spirit of jazz. O'Keeffe's early and late work with its simplified forms and vibrancy may be seen to have some relationship to Matisse. Indeed, some critics early in the twentieth century compared O'Keeffe with Matisse. Lewis Mumford, for example, wrote an article entitled "O'Keeffe and Matisse" that reviewed two concurrent shows of the two artists and established a kinship between them. As Mumford noted, "Miss O'Keeffe's paintings . . . reveal and refocus many of the dominant aspects of our time. It is the same with Matisse."[30]

Matisse, like Rodin and O'Keeffe, was probably familiar with the famous passage from Nietzsche's *The Birth of Tragedy*, "In song and in dance man expresses himself as a member of a higher community; he has forgotten how to walk and speak; he is about to take a dancing flight into the air. . . . He feels himself a god whom he saw walking about in his dream."[31]

Rodin and Matisse, and O'Keeffe more indirectly, were influenced by the productions of the Ballets Russes, the "child" of the Russian impresario, Sergey Diaghilev, that startled the world with its experimental productions. Matisse actually designed the decor for Diaghilev's 1920 production of *Le chant du rossignol*.

On January 11, 1916, Diaghilev and his Ballets Russes arrived in New York City for the first of two lengthy tours of the United States. That spring, on April 12, the famed dancer Vaslav Nijinsky made his debut in New York in *Le Spectre de la rose* and *Pétrouchka*. In late February, O'Keeffe, having accepted a job for the fall as head of the art department at West Texas State Normal College in Canyon, Texas, left Columbia, South Carolina, where she had been teaching, to come to New York to complete her courses with Arthur Dow at Columbia University before moving west. It is unclear whether O'Keeffe actually attended any of the performances, but she certainly would have seen the controversial publicity surrounding some of them, particularly the Stravinsky works. Nijinsky's white-petaled costume designed by Léon Bakst for *Le Spectre de la rose*, cannot help but remind one of O'Keeffe's later rose paintings, particularly her *Abstraction, White Rose No. 2* (pl. 23) and *Abstraction, White Rose No. 3* (pl. 24), which emphasize movement and effervescence more than the flower itself. Bakst's flowing designs also share some affinity with O'Keeffe's early watercolors. Like O'Keeffe, Bakst used flowing curvilinear forms that are distinctive and alluring. For example, one may compare Bakst's *Faun*, a watercolor and gouache design for Nijinsky's costume in *Prélude à l'après-midi d'un faune*, a ballet based on the composer Claude Debussy's musical composition, with O'Keeffe's 1916 watercolors *Blue Nos. 1–4* (see pls. 1–4), where the fluid, flowing blue areas of color celebrate movement and fantasy. Although there is no figure in O'Keeffe's pieces, there is a bodily "presence" in these and other early watercolors.

Besides the presence of the Ballets Russes in New York, other dancers and trends in

dance in Europe and America remained influencial. These dancers inspired artists and photographers and represented a new freedom of the body.

Dance has been perceived as the oldest and most primitive art form used as part of rituals and frequently as the primitive expression of religion and love. For some cultures, such as that of the Native American Omaha people, the same word meant both to dance and to love. The magical operation for the attainment of a particular end—harvest, fertility—was not performed by only the legs and feet. In some cultures, such as the South Sea Islands, the hands and fingers alone were the essential components for dance; dancing could even be carried on in a seated position, as in Fiji Island dance. The turn-of-the-century interest in Europe and America in "primitive" and exotic cultures included an interest in dance as well as the other arts.

In America, the dancer became a symbol for the New Woman in the early twentieth century, for the physical and the artistic were united through dance. Three early solo figures who were important for O'Keeffe were Loïe Fuller, Isadora Duncan, and Ruth St. Denis. Fuller, a young American from Illinois, became a sensation in both Europe and America as her twirling draperies enveloped her body and she captured nature through technical means—her dance, new electric lights, and swirling silk (fig. 5). She embodied natural forms in her Fire Dance, her Lily Dance, and her Serpentine-skirt dances, as spirals, curves, and waves miraculously appeared and reappeared in new guises glowingly transfigured on stage. Rodin and Mallarmé particularly admired her. Upon viewing photographs of Fuller, one cannot help but think of the flame forms that O'Keeffe uses, as well as O'Keeffe's flower paintings, which frequently evoke aspects of the human form.

Isadora Duncan also incorporated drapery into her work, but returned to the Greeks for her inspiration (fig. 6). Duncan's dance vocabulary also had roots in François Delsarte's manuals that stressed pantomime and gestures, and having a dynamic flow. The Delsarte system had nine laws of gesture and posture on which he based his exercises for freedom and relaxation for each part of the body. The purpose of these exercises was to educate the body to articulately express emotions and ideas. The Viennese-born Swiss musician, Emile Jaques-Dalcroze also emphasized music and rhythmic movement as significant in educating the whole being and in creating a new sense of self. Unlike the frenzy of a Bacchic rite, Jaques-Dalcroze and Delsarte, like Platonic philosophy, recommended soothing and calm gestures. And, as for Plato, dance was not only an exercise for the body, but also an art that came from the gods and pleased them.

Duncan expanded on the Delsartean vocabulary and began to interpret Chopin, Beethoven, Bach, Schubert, and other composers, often wearing a Greek tunic and dancing in bare feet. Dancing was no longer polite, but intuitive and empowering.

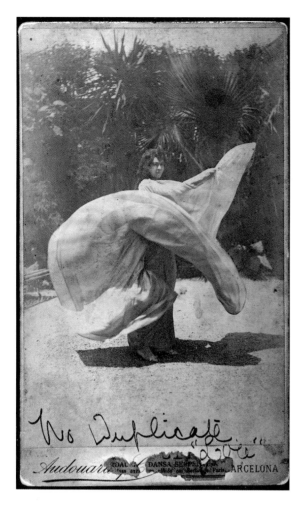

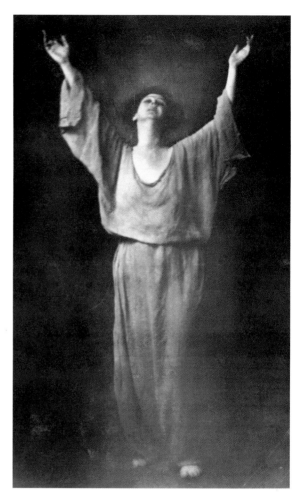

Figure 5. Loïe Fuller, 1900? Dance Collection of The New York Public Library.

Figure 6. Isadora Duncan, 1916. Dance Collection of The New York Public Library.

St. Denis, also influenced by Delsarte and Jaques-Dalcroze, made Oriental dancing part of her "modern" dance technique. Asian beauty and contemplation were combined with Western imagination. Like Duncan and Fuller, St. Denis was self-taught and enthralled her audiences with her exotic costumes and settings. One writer, Hugo von Hofmannsthal, in 1907, wrote about her dancing, "I feel that something here has, like a flame, penetrated the real and sensuous. . . ."[32] The metaphor of the dance as a flame was prevalent among writers of this time. The flamelike forms in O'Keeffe's work, particularly pieces such as *Blue and Green Music* (see pl. 22) and *Special No. 9* (fig. 7), may be seen as visual metaphors for the dance. Hofmannsthal wrote further of St. Denis, envisioning her dancing the role of Salomé, "Every limb being tested, vain self enjoyment of the limbs' own harmonies. Everything is here

to serve, each sphere and form of nature used up by this servitude. The gesture perceived as the acme of existence. . . . Touch of nocturnal air. The flame of a torch dying down, a shadow on the ground."[33] And of St. Denis's slow-measured and graceful movements, like those of Javanese and Cambodian dancers who had come to Europe for the first time in 1889, Hofmannsthal wrote, "It is of course, the same that all Oriental dances are aiming for: the dance, the dance as such, the silent music of the human body: the rhythmical flow of unceasing and true movements, as Rodin has put it."[34]

The writer and poet Paul Valéry also turned to the metaphor of the flame in his symposium *L'Âme et la danse* (*The Soul and the Dance*). Valéry has Socrates speak eloquently about the dancer, "Does she not look as though she was living quite at her ease in an element

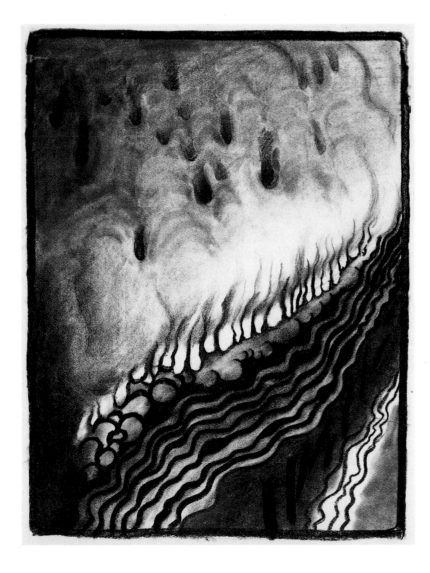

Figure 7. Georgia O'Keeffe, *Special No. 9*, 1915. Charcoal on paper, 25 x 19 1/8 in. The Menil Collection, Houston (85-037 DJ).

comparable to fire, in a highly subtle essence of music and motion, while she inhales inexhaustible energy . . . O flame! Living and divine! But what is a flame, if not the movement itself?"[35] Valéry saw dance as a kind of state of intoxication and the dancer as capable of carrying others to that state. The dancer was a wave "celebrating the mysteries of absence and presence."[36] O'Keeffe's frequent use of wavelike forms, as well as the flame, may have meanings analogous to Valéry's imagery.

St. Denis with her husband, Ted Shawn, formed the famous Denishawn School, which fostered modern dance throughout America. While touring throughout the country and abroad, Shawn and St. Denis studied Native American dances in the Southwest and native dancers of Mexico, Asia, and elsewhere, incorporating ethnic elements into their own dance pieces (fig. 8). A number of their dances incorporate circular, spiral, and wavelike forms also found in O'Keeffe's painting and sculpture.

Both the Denishawn School and Duncan's schools incorporated outdoor exercise and dance performance into their programming, thereby intertwining nature, music, and movement of the human body. Beginning in 1916, open-air pageants became popular throughout the country, following a majestic large-scale production of St. Denis, Shawn, and one hundred dancers depicting the life and afterlife of Egypt, Greece, and India during the mythological period. Pageants became a craze in many small towns throughout America.

One specific dance called *Soaring*—choreographed and performed by the Denishawn dancers to the music of Chopin performed by Louis Horst—was performed outdoors and incorporated music, movement, and shimmering gauze material colored by filtered lights (fig. 9). The piece suggested elements of flight as well as young budding plant forms. This plant imagery can be likened to O'Keeffe's own plant forms—her flowers, trees, etc. An early design of O'Keeffe's for a stained-glass window for a swimming pool in the Rocky Mountain Country Club, appearing in the August 1917 issue of *Vanity Fair*, shows O'Keeffe's awareness of a growing trend of "back to nature" dancing as a significant form of self-expression. In her design—"The Frightened Horses and the Inquisitive Fish"—one finds stylized dancers set against towering waves. Almost twenty years later, in 1936, O'Keeffe was commissioned for $10,000 by Elizabeth Arden to paint a new flower painting, *Miracle Flower*, as a background for Arden's new Gymnasium Moderne, where rhythmic dancing and eurhythmic exercise were emphasized, thereby continuing the connection between dance, nature, and the visual arts.

A student of the Denishawn School in the 1910s, the young Martha Graham, who first appeared in New York in 1923, also made her mark on the dance and artistic world (fig. 10), and may be seen to have a connection to O'Keeffe's work. Graham went beyond Denishawn

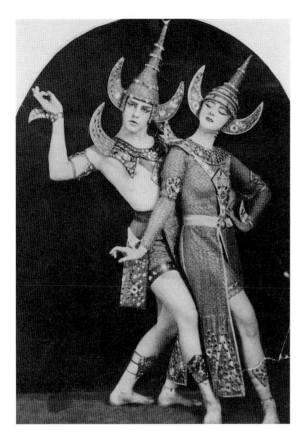 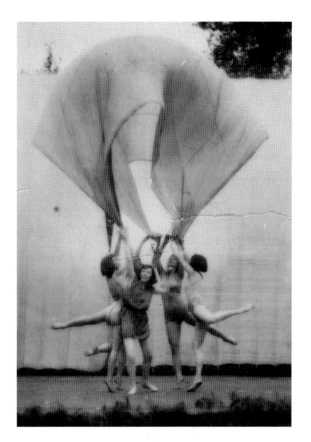

Figure 8. Ted Shawn and Ruth St. Denis in *Rama Sita*, c. 1923. Peterborough Historical Society, Peterborough, New Hampshire.

Figure 9. *Soaring* performed by Denishawn students at The Mariarden Theater, 1922. Peterborough Historical Society, Peterborough, New Hampshire.

in her spare direct choreography, believing that dance could be an abstract equivalent of individual lives that include pain, anger, glory, and so forth. Where Denishawn dances frequently evoked exotic cultures using veils, beads, and other flowing materials, Graham's works were often carefully constructed pictures of movement—and stillness, for plastic still images were seen as an important part of the formal choreography. For Graham, who moved beyond visualized music, it was the muscular tension inside a dancer's body, the unheard "music" of dance, the still points, that were important in combination with movement. Graham's work also combined affect and discipline, which were considered feminine and masculine traits; in doing so, her work suggested the union of sexual polarities.

Graham's evocation of equivalents has clear analogies to Stieglitz's series Equivalents and to O'Keeffe's work of the same time. Her "still" images have an affinity to O'Keeffe's

Nude Series (see pls. 7–19) as well as later work such as the Pelvis paintings where bodily shapes and rhythms are evoked. Some critics have directly connected Graham and O'Keeffe:

> *The parallels between O'Keeffe and Graham are indeed striking: Both drew inspira-*
> *tion from the landscape of the American Southwest, both became entangled in social*
> *rhetoric that promoted even as it imprisoned their careers, both were understood to*
> *create—moreover to incarnate—metaphors for the feminine, the unconscious, and an*
> *unrecognized America. Although O'Keeffe fought long and hard to dispel the sexual*
> *connotations her work as a female modernist evoked among critics, Graham attempt-*
> *ed to elude this kind of assessment by associating her physical appearance from the*
> *beginning with strength and economy. Whereas O'Keeffe withdrew from sexual identi-*
> *ty, opting for an androgynous relationship to her work, Graham occasionally inflect-*
> *ed her movement with masculinized and/or mechanized traits.*[37]

One may compare, for example, Graham's *Primitive Mysteries* (1931) with some of O'Keeffe's work. Graham worked on the dance after she and Louis Horst had returned from a trip to

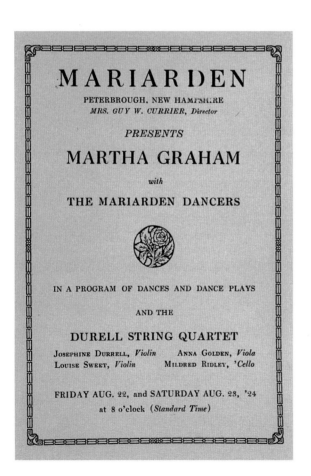

Figure 10. Program of a Martha Graham dance performance at The Mariarden Theater, 1924. Peterborough Historical Society, Peterborough, New Hampshire.

opposite:

Figure 11. Martha Graham in *Primitive Mysteries*, date unknown. Dance Collection of The New York Public Library.

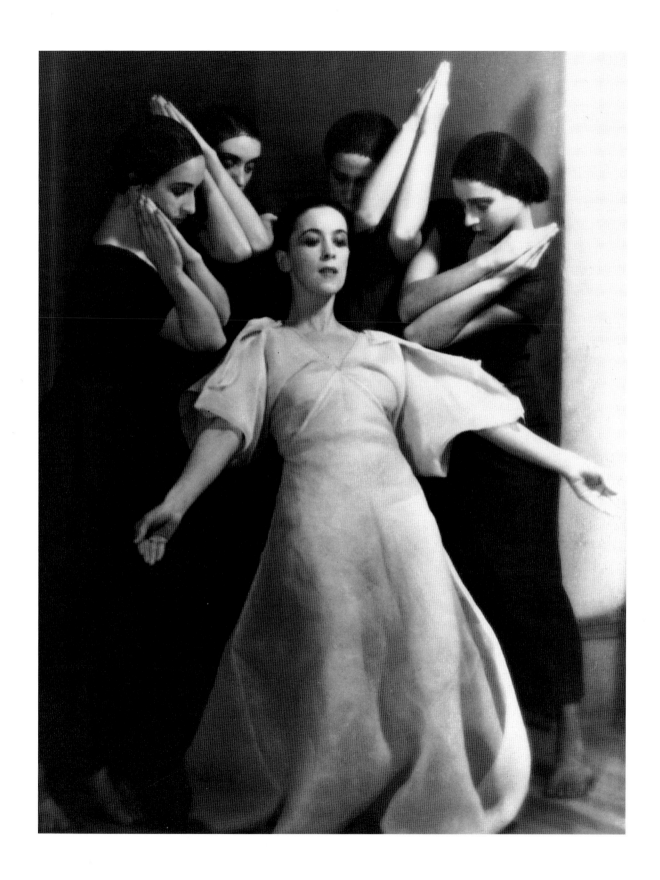

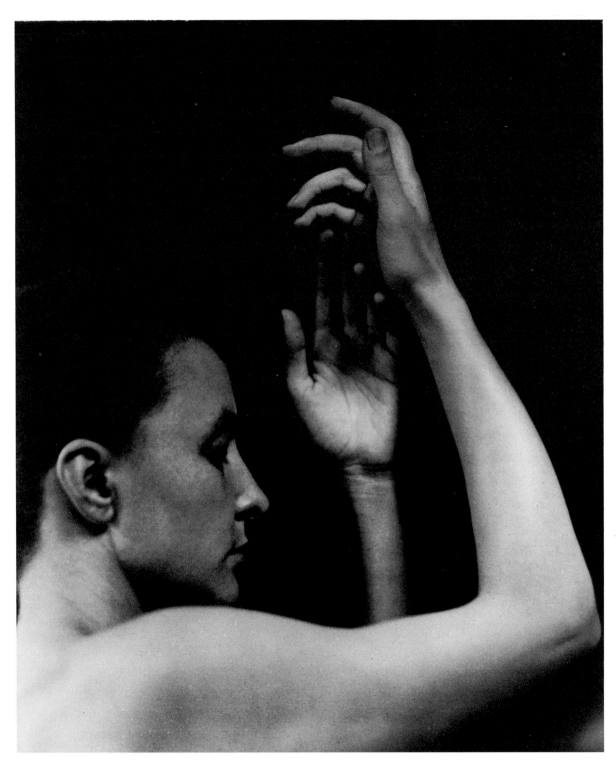

Figure 12. Alfred Stieglitz, *Georgia O'Keeffe*, 1920. The Metropolitan Museum of Art, New York (28.127.2), gift of David A. Schulte, 1928.

the American Southwest in the summer of 1930. The light and the landscape there excited her as they had O'Keeffe. She was inspired, too, by the ceremonial dances of the Pueblo, Hopi, and other Native American peoples, as well as the juxtaposition of paganism and Catholicism. In *Primitive Mysteries*, there is an emphasis on circular movement, as Graham appears in a diaphanous white dress, among a group of twelve women in long, deep blue dresses. Graham's profoundness, like O'Keeffe's, lies in the significance of form, which is definitive yet rooted in mystery and elemental feelings. A photograph of Graham in "Hymn to the Virgin" from *Primitive Mysteries* (fig. 11) suggests the open, frontal qualities of some of O'Keeffe's flower paintings or the flowing forms of some of her tree paintings.

In general, as Elizabeth Kendall noted in 1979, by

> *1916 dance meant something very substantial to Americans . . . dance was an impor-*
> *tant but indefinable presence. . . . There were no terms in ordinary language to dis-*
> *cuss it. But physical culture enthusiasts—the women who made their families take*
> *the fresh air, the men who did exercises—connected artistic dance to an ideal state of*
> *the body and therefore the soul. . . . Dance was part of the nostalgia of this time,*
> *part of its pastoral longings, part of that impulse to find a freer, simpler relation to*
> *the physical world in the midst of the overwhelming rush to industrialize. And a*
> *mythological-type dance was pictured not only in people's minds, but in the popular*
> *graphics they saw around them—in drawings, posters, cartoons, rotogravure photos,*
> *and moving pictures.*[38]

The prevalence of dance imagery in America, particularly in the 1910s, may be, in part, traced to the work of American photographers who explored dance imagery, especially those working in the pictorial mode who used a soft focus to capture a sense of mystery, sensuality, and spirituality thought to be inherent in the dancing figure. These photographers include Edward Steichen, Edward Weston, Anne Brigman, George Seeley, Clarence White, Arnold Genthe, and Baron Adolf de Meyer, who came to the United States in 1914. Stieglitz's *Camera Work* fostered all the arts, and Stieglitz himself photographed O'Keeffe in several images with her arms raised in the stylized gestures of an Asian dancer (fig. 12). His many photographs of O'Keeffe's hands in various poses also have roots in the gestures of dance. In 1916, *Vanity Fair* magazine ran monthly aesthetic-dance-photography features, which included a series of photographs of Duncan's school in Rye, New York, and a story about Virginia Myers, a celebrated child dancer, whom the critic Hutchins Hapgood had also referred to in *Camera Work*. Hapgood saw the little girl as an example of an endangered life force whose spirit was being crushed by conservative authorities.

Other artists besides photographers connected to the Stieglitz galleries were also involved with music and dance. The artists' works and their presence, of which O'Keeffe would have

known through Stieglitz, formed a significant part of the milieu in which O'Keeffe worked. The French artist Francis Picabia, who championed music and art parallels, had his first one-man show in the United States in March 1913 at 291. Picabia had come to New York in 1913 to attend the controversial Armory Show, which for the first time exposed Americans to experiments in modern art. Among Picabia's works shown at 291 were those whose basis lay in music and dance, such as *Chanson nègre I* and *II* (*Negro Song I* and *II*) (both 1913), *Danseuse étoile et son école de danse* (*Star Dancer and Her School of Dance*) (1913), and *Danseuse étoile sur un transatlantique* (*Star Dancer on a Transatlantic Liner*) (1913). The star dancer was the popular dancer Stacia Napierkowska, who was en route to America for a tour when the Picabias met her. Five of Picabia's abstractions were left with Stieglitz, all of which O'Keeffe probably saw.

Picabia's theories were taken up by the curious press. In a 1913 interview with Hutchins Hapgood, Picabia declared, "Art resembles music in some important respects. To a musician the words are obstacles to music expression . . . the attempt of art is to make us dream, as music does. It expresses a spiritual state, it makes that state real by projecting on the canvas the finally analyzed means of producing that state in the observer."[39] Picabia's theories led him to abstraction as he sought to leave behind the observed external world.

O'Keeffe was probably first aware of Picabia's painting through his piece entitled *Danses à la source I* (*Dances at the Spring I*) (1912), as well as through his famous statement in a *New York Tribune* interview that Eddy quoted. Part of Picabia's statement included the following: "I improvise my pictures as a musician improvises music . . . creating a picture without models is art . . . we moderns, if so you think us, express the spirit of the modern time, the twentieth century, and we express it on canvas the way great composers express it in their music."[40] O'Keeffe went in January 1915 to see Picabia's three large abstractions, *Je revois en souvenir ma chère Udnie* (*I See Again in Memory My Dear Udnie*) (c. 1914), *C'est de moi qu'il s'agit* (*It's About Me*) (c. 1914), and *Mariage Comique* (*Comical Marriage*) (1914). His large biomorphic shapes and thick bisecting lines may be seen in a number of O'Keeffe's pieces, such as *Black Spot III* (1919) or *Spring* (1922). A number of Picabia's pieces have organic plantlike forms associated with dance and music similar to some of O'Keeffe's abstracted flower pieces such as her *Flower Abstraction* (pl. 25), and somewhat similar to an early O'Keeffe sculpture. For example, one sees in *Je revois en souvenir ma chère Udnie* (*I See Again in Memory My Dear Udnie*) (fig. 13) the flowing magenta, orange, mustard, and gray forms that celebrate movement, color, and seeming new life and growth in the organic forms. Some of Picabia's shapes are like petal forms, exuding openness and newness inspired by the dancer Udnie.

A Stieglitz photograph from his composite portrait series of O'Keeffe, *Show at 291,*

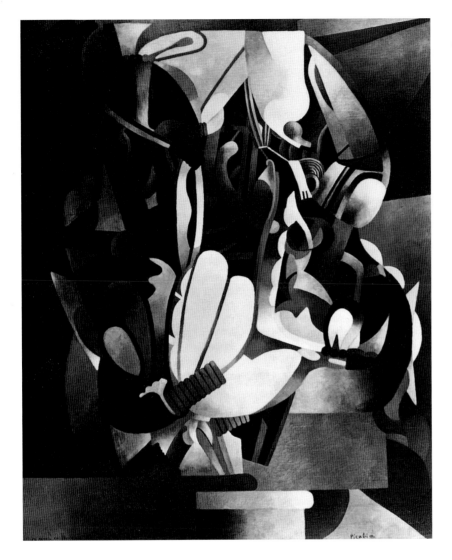

Figure 13. Francis Picabia,
*Je revois en souvenir ma
chère Udnie (I See Again in
Memory My Dear Udnie),*
c. 1914. Oil on canvas,
8 ft. 2 1/2 in. x 6 ft. 1/4 in.
The Museum of Modern
Art, New York, Hillman
Periodicals Fund.

1917, reveals O'Keeffe's early plasticine phallic or budlike sculpture placed close to O'Keeffe's drawing *Special No. 12* (1917), thereby uniting male and female principles. Here the male and female elements seem to dance as the sculpture and drawing appear to gesture to each other. A 1918 Stieglitz photograph shows the same sculpture with O'Keeffe's feet placed gently on the sculptural base—a symbolic gesture in silence, for the foot, besides being associated with dance, is also a transcultural symbol of the strength of the soul. This sculpture also appeared bowing to the viewer in a 1919 Stieglitz photograph of O'Keeffe's painting *Music–Pink and Blue No. 1*. The sculpture is placed "in" the large blue aperture. Some critics have interpreted this photograph as suggesting the significance of sexual intercourse as an energizing force. The title *Music* could also emphasize the theatrical and ethereal qualities of

the painting and photograph, particularly given the importance of Kandinsky's writings for O'Keeffe, with his emphasis on the color blue as heavenly.

Picabia's non-objective watercolor *La musique est comme la peinture* (*Music Is Like Painting*) (c. 1913–17) was shown at the 1917 Society of Independent Artists in New York. With its rising partial arch and arch forms, it is reminiscent of van Doesburg's *Symbolist Composition*. Picabia, however, employed more precise clean-edged lines. The Picabia piece may well have influenced O'Keeffe's use of rising arched linear elements on a dark field in works such as *Orange and Red Streak* (1919), *From the Plains I* (1919), or *From the Plains II* (1954). Although O'Keeffe probably never met Picabia, she certainly knew his work and knew of his warm correspondence with Stieglitz after he left the United States in 1917.

Picabia, like a number of artists and intellectuals, was also interested in theories relating to the "fourth dimension." The fourth dimension signified an ideal or higher dimensional reality, best attained by means of new spatial perceptions based on tactile and motor sensations, such as those experienced via music and dance. For some, a new space would be created, which denied a clear-cut three-dimensional reading as traditional academic paintings might, but suggested instead the possibility of a new "fourth" dimension. Fourth dimension theories were also introduced to the Stieglitz circle by Max Weber, who was a close friend of Stieglitz's until about 1911 and who also did several paintings with music as their basis. The Steiglitz circle became further imbued with fourth-dimension theories through the arrival of Mabel Dodge, a wealthy Buffalo socialite who attracted the artistic and intellectual avant-garde to her salons, and through the young architect Claude Bragdon, who had written *A Primer of Higher Space (The Fourth Dimension)* in 1913. O'Keeffe and Stieglitz became friends of Bragdon's when they moved into the Shelton Hotel in 1925 where Bragdon had lived since 1924. He had long been interested in correspondences between art and music, as had Stieglitz, and had attended a legendary color organ performance of Aleksandr Scriabin's called *Prometheus: The Poem of Fire* in March 1915 at Carnegie Hall.

Friendly with Max Weber and also exhibiting at 291 was the Russian-born Abraham Walkowitz, who became noted for his drawings and sketches of Isadora Duncan. Walkowitz, who had met Duncan at Rodin's studio in Paris, made more than five thousand drawings and sketches of the famed dancer, capturing her graceful movement in linear lyricism. His curvilinear elements in some of the almost abstract images remind one of the spiral and curved lines of some of O'Keeffe's early work. It was Walkowitz who persuaded Stieglitz to show children's art in 1912 and to show O'Keeffe's work in 1916.

In 1915 Stieglitz gave the German-born Oscar Bluemner his first one-man show in America. Bluemner, too, was captivated by the relationship of the visual arts and music, or as he noted, "the musical color of fateful experience."[41] Further, there was seen to be a rela-

tionship between landscape elements and various states of human emotion, a thesis based on Bluemner's study of Chinese and Japanese aesthetics. Bluemner wrote, "My idea fully established: colors like music can excite moods and express their emotions, are psychic agents or stimuli. . . ."[42] Bluemner's intense colors and forms, his strong suns, moons, and other nature forms were to influence O'Keeffe and other artists of the Stieglitz circle such as Arthur Dove, who did his own series of intense suns and moons. The glowing, centrally located sun in O'Keeffe's *Red Hills and Sun, Lake George* (1917) shows much similarity to Bluemner's

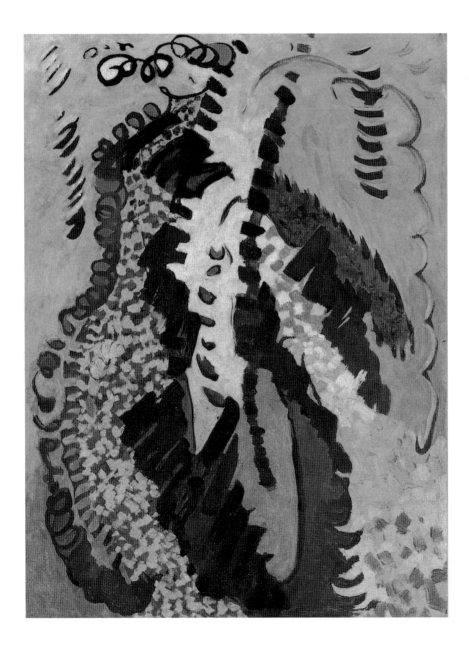

Figure 14. Arthur Dove, *George Gershwin–I'll Build a Stairway to Paradise*, 1927. Ink, metallic paint, and oil on paperboard, 20 x 15 in. Museum of Fine Arts, Boston (1990.407), gift of the William H. Lane Foundation.

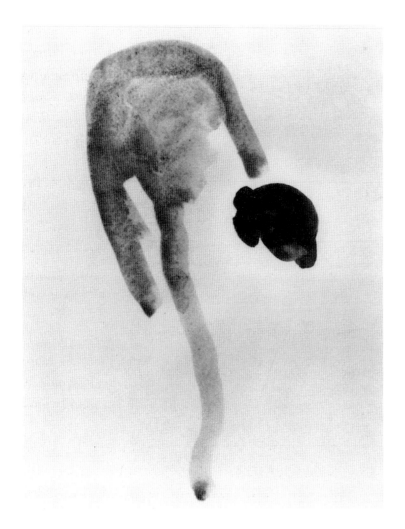

Figure 15. Georgia O'Keeffe, *Leah*, 1917. Watercolor on paper, 15 x 11 in. Location unknown.

paintings, such as his *The Eye of Fate* and *Sun Storm* (both 1927). Bluemner wrote an exhibition flyer for O'Keeffe's 1927 showing at the Intimate Gallery. He emphasized their common vision of the landscape as having a bodily presence and as an emblem of a deep personal feeling. Arthur Dove in 1928 wrote of Bluemner's painting *The Red Moon* and other paintings exhibited in 1927 at the Intimate Gallery, "It burns harder than fire. I like that sort of heat . . . the things are fine, way back and way on in music and in wisdom."[43]

Dove, who was a friend of O'Keeffe's, and greatly admired by her, too, became deeply involved in incorporating explicit allusions to music in his abstractions, e.g., *Music* (1913), *Sentimental Music* (1917), *Chinese Music* (1923), and his jazz paintings—the 1927 pair based on George Gershwin's *Rhapsody in Blue*, for example, which premiered in New York in February 1924, and *George Gershwin–I'll Build a Stairway to Paradise* (fig. 14). The linearity of the jazz paintings with their sense of improvisation and directness, heightened by the use

of metallic paint, conveyed the immediacy of jazz improvisation and the increasing tempo of modern twentieth-century life. It is interesting to note that Ira Gershwin, the composer's brother, suggested the title for the musical composition following a trip to The Metropolitan Museum of Art where he had just viewed Whistler's paintings including *Nocturne in Blue and Green*. O'Keeffe's own paintings with large areas of blue, such as her *Music–Pink and Blue Nos. 1* and *2* (see pls. 5 and 6), or her later Pelvis paintings, may well be seen as rhapsodies in blue themselves, when viewed in a synaesthetic context.

The power of dance was also seen in some of Charles Demuth's watercolors such as his *Vaudeville* (1917). Demuth, also a member of the Stieglitz inner circle and a friend of O'Keeffe's, frequented New York's Greenwich Village cafés and nightclubs. Without concrete spatial background imagery, Demuth's dancers exude a sense of tempo, rhythm, and grace, dancing into infinity. One finds the same kind of grace, although more abstractly executed, in some of O'Keeffe's nudes, such as *Leah* (fig. 15). Here abbreviated watercolor washes suggest the movement of the female form.

In 1917, Stieglitz showed the work of Gino Severini, the Italian Futurist, at 291. Severini's drawings and paintings of dancers, more lyrical than earlier work that was more characteristic of the Futurist aesthetic, evidence a rhythmic interplay of light and color. A number of these pieces were seen to encompass elements of a "fourth dimension," which inspired Stieglitz and his contemporaries, as had the Picabia pieces.

In 1917, Stieglitz also gave Stanton Macdonald-Wright—a founder of the Synchromist movement along with Morgan Russell—his first one-man exhibition in New York at 291. (In 1916, Stieglitz had shown Macdonald-Wright's work in a group show at 291 that included O'Keeffe, Marsden Hartley, John Marin, and Abraham Walkowitz.) Russell and Macdonald-Wright were influenced by Ernest Tudor-Hart, who stressed a musical system of color harmony based on psychological rather than physical equivalents. Macdonald-Wright thought in terms of chords based on triads of colors and was aware of the emotional values of colors. By equating color chords of the chromatic circle with equivalent notes of the musical scale, the Synchromists sought a harmonious and balanced spectrum. As one might guess, the name of the movement had some association with "symphony." For Macdonald-Wright, as for Kandinsky, blue was the color of the ethereal, of softness, of antimaterialism, and inspiration; blue-green had a quality of remembered things, of nostalgia.

O'Keeffe admired Macdonald-Wright's work and the Synchromists in general from the time she first was exposed to their work in 1914–15 at 291. In 1917, O'Keeffe met Macdonald-Wright, and in 1918 she would have seen his *Oriental Synchromy in Blue Green* (1918) exhibited at the Daniel Gallery. O'Keeffe's 1919 paintings, *Blue and Green Music* (see pl. 22), and her two versions of *Music–Pink and Blue Nos. 1* and *2* (see pls. 5 and 6) may be seen as

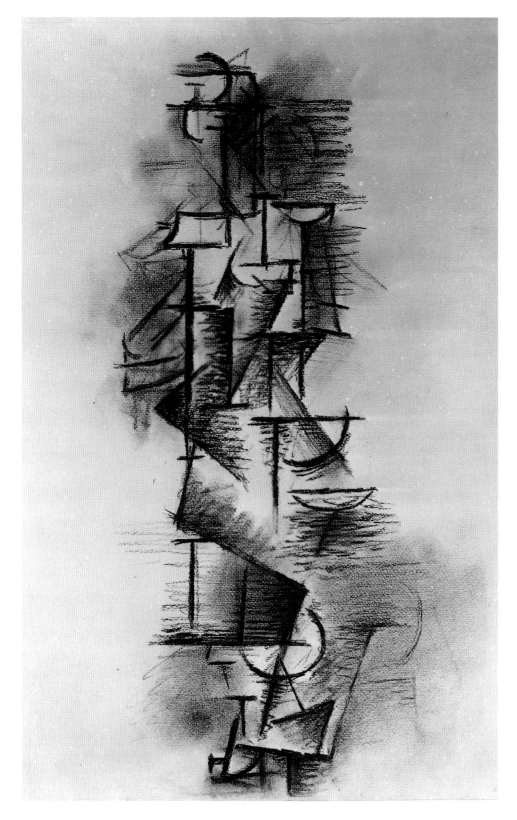

Figure 16. Pablo
Picasso, *Standing
Female Nude*,
1910. Charcoal,
19 1/16 x 12 5/16 in.
The Metropolitan
Museum of Art,
New York, Alfred
Stieglitz Collection
(49.70.34), 1949.

an homage to Macdonald-Wright's work. As did Macdonald-Wright and Russell, so, too, did O'Keeffe seem to create, through color dynamics, a formal metaphor of movement and rhythm that at times evokes aspects of the human body.

O'Keeffe's affinity for music forms is also seen in her own musical skills and preferences. She played the violin and, by her own account, played until her fingers were sore in the evenings, and then worked on the new drawings she did in 1915 in Columbia, South Carolina, while teaching there. The new abstractions, so different from anything she had done before, sung with new life. Indeed, the first tube of drawings O'Keeffe sent to her friend Anita Pollitzer in New York was accompanied by the words, "Tell me—do you like my music?"[44] O'Keeffe appeared to use musical metaphors in her conversation and writing as well as in her artwork. She later wrote to Pollitzer about the impact of a Picasso Cubist drawing, *Standing Female Nude* (fig. 16), that appeared in *Camera Work*, calling the drawing "wonderful music." "Anita, I can't begin to tell you how much I have enjoyed that *Camera Work*— It surprised me so much—and you know how much I love what is inside of it—That Picasso Drawing is wonderful music isn't it—"[45] O'Keeffe's words, although brief, perhaps summarize the importance of music for her. Given that O'Keeffe had seen a number of Cubist works, it does not seem impossible to speculate that some of O'Keeffe's spiral and scroll-like forms might be viewed as abstractions, even if unconscious, related to the upper scroll-like form of a violin, where music is evoked through suggestion. One also finds, as precedent, the scroll of a large bass violin used to suggest the orchestra in some pieces by Degas, such as his 1878 pastel *Ballet Dancer*, where the dancer, brilliantly lit by gaslights of the stage, dances like a large blue flower, interacting and contrasting with violin. The looming scroll shape appears quite abstract.

Music was important for O'Keeffe throughout her life. A photograph of a music shelf by Myron Wood shows a variety of records—Johann Sebastian Bach, Beethoven, Schubert, Claudio Monteverdi, Orazio Vecchi, Marlene Dietrich, and so forth. Above the records are antlers that twist gracefully in dancelike gestures. Since music and dance were so important to O'Keeffe and were important in her cultural milieu, let us look further at some of her works that have their roots in music and dance. As one studies some of these works, it is perhaps important to understand the roots of the word *music*, which goes back to classical antiquity. The word is derived from the Greek *Mousikos* and refers to the nine muses of the ancient world. Initially associated with the god Apollo, the muses were the deities of song and poetry. As female personifications of artistic inspiration and creativity, women thus came to be associated with the imagery of music. These female connotations have contributed to the linking of the muses and music with Venus, the goddess of love. This association of music and love seems natural owing to the sensual quality of much music. Early depictions of

music with angels playing musical instruments suggest the ethereal, heavenly qualities of musical representation. The suggestion of female bodily forms in some of O'Keeffe's works, in combination with her interest in musical elements, seems a natural continuation of the earliest understandings of "music."

Important, too, is the spiral form that appears and reappears in O'Keeffe's work. The spiral itself is a familiar symbol of a dynamic force that speaks of both transition and transcendence through its circular movement toward a center. The spiral is also a basic component of many dance forms throughout the centuries and appears in dance notations to this day.

The spiral may also be linked to the shape of a snake or serpent and its relation to early goddess figures. O'Keeffe was fascinated by this shape and in her later years had a skeleton of a rattlesnake displayed in a glass-covered inset in the adobe *banco* in her living room in Abiquiu. The spiral and wave forms that O'Keeffe so frequently uses may perhaps be better understood in the context of an early Pelasgian creation myth that tells of Eurynome, goddess of all things, rising from chaos. As she divides the sky from the waters, she begins to dance on the waves. Out of the wind generated by her dance she creates a serpent named Ophion who coils about her. A universal egg is created, and Ophion coils about the egg until it hatches. The sun, the moon, planets, stars, earth, and man and woman are thus born. The serpent and its spiral or coiled shape is therefore sometimes seen as an androgynous blending of male and female, although it is probably more frequently seen as female. In O'Keeffe's case, given her denial of any specific female or sexual imagery, her use of the spiral form is perhaps best viewed in terms of its general creative or transcendent symbolism and its dance-like movement.

O'Keeffe's 1914 and 1915 drawings illustrate her early use of this spiral form. In her *Special No. 32* (1914), for example, orange-red curvilinear forms move lyrically through a field of blue, green, and yellow. As Art Nouveau images of the time, such forms also suggest the curved budding forms of new plant growth. In *Special No. 7* (1915), one finds an abbreviated or abstract spiral with gentle vertical wave forms. Here is a musical harmony of charcoal gradations. The undulating forms may be seen to have some connection to Picasso's 1910 *Standing Female Nude* (see fig. 16), which Stieglitz owned and which was reproduced on three different occasions in *Camera Work*, where O'Keeffe saw it and referred to it as "wonderful music" (see note 45). In *Special No. 8* (1915), the spiral has become more intense and resonant, recalling the work of some of the Symbolists, such as Odilon Redon. This image was translated into paint in her *Blue No. 1* (see pl. 1). In *Untitled* (1915), O'Keeffe has transferred the spiral form into an eerie landscape where a budding stalk and spiral are uncurling from a pulsating mound containing partial spiral forms. A dark serpentine wave floats

through the background. Here, an androgynous and anthropomorphic creation dances alone in a haunting landscape.

In another charcoal drawing of 1915, *Special No. 9* (see fig. 7), flamelike forms, rising from dark wave lines recall the association of the flame with dance and also foreshadow O'Keeffe's *Blue and Green Music* (see pl. 22). Some of these early charcoal drawings were sent to Stieglitz via O'Keeffe's friend Anita Pollitzer, the first roll of drawings being seen on Stieglitz's fifty-second birthday, New Year's Day, 1916. As these works had no precise subject matter, Stieglitz responded to them as an equivalent to the artist's interior self and that "perhaps only on stage in the work of Eleanora Duse or Isadora Duncan had he witnessed its equal. Finally, at fifty-two, he had discovered a woman who performed in his own medium: paper."[46] Thus, Stieglitz quickly saw the intensity and freedom inherent in O'Keeffe's work that had real affinities and connections with new experiments in dance and performance.

Drawing #14 (1916), for example, done while listening to a record in one of Dow's classrooms at Columbia University, represents O'Keeffe's perhaps most deliberate early attempt at synthesizing music with art. Almost identical in composition is her *Black Lines (Abstraction)* (fig. 17). Both were done as O'Keeffe departed from her academic background and began to travel the road toward modernism. The two-dimensional flat forms are presented in a calligraphic manner similar to that of a Japanese woodcut. Like a composer of music, O'Keeffe creates visual music through harmony and balance. The jet black diagonals stand in contrast to the more subtly applied charcoal "wash." The repetition of the small "sparks" suggestive of two colliding forces, allude to motion, energy, and sound. A later version of this same kind of imagery, *Black Diagonal* (1919), shows a thrusting dark diagonal laid over a fragile coiled shape.

In 1916, O'Keeffe also referred more directly to the lyricism of the forms and movement of the human body in her *Abstraction IX*, where she reduced a likeness of her friend and fellow student Dorothy True to a few essential flowing forms.

By 1917, O'Keeffe had produced more lyrical and complex spiral forms, such as *Special No. 12* (fig. 18), where the subtle hues of charcoal gradation dance and pulsate freely in an open space that knows no bounds. And in 1917, O'Keeffe completed a series of nudes in beautiful watercolor washes that move freely in an unbounded space (see pls. 7–19). O'Keeffe's overlapping and merging areas of color give her figures a sense of dynamism and vitality—Bergson's *élan vital*—in much the way Rodin had done. There is some evidence that the figures were inspired by young Leah Harris, who was employed in Texas by an extension program of the county agricultural department teaching canning and food preservation to Panhandle housewives. Meeting in Texas, both nearly thirty, O'Keeffe and Harris became close friends. O'Keeffe was also warmly welcomed by Harris's family. Although a number of the nudes are seated, there

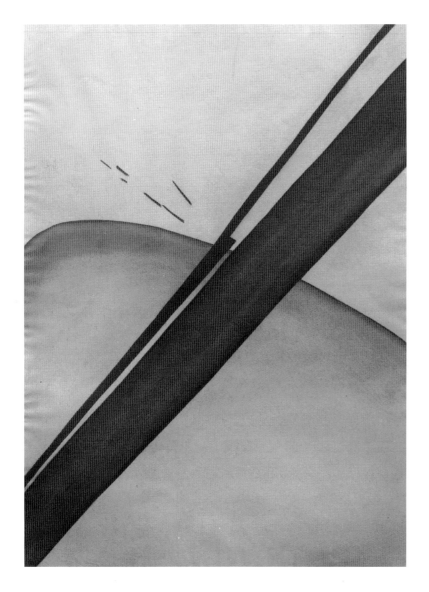

Figure 17. Georgia O'Keeffe, *Black Lines (Abstraction)*, c. 1918. Charcoal on paper, 24 9/16 x 18 3/4 in. Addison Gallery of American Art, Phillips Academy, Andover, Massachusetts (1959.22).

is a strong sense of the dance as the watercolor washes flow and merge, emphasizing space as well as form.

Some of the nudes, such as numbers VII and XII (see pls. 14 and 19), evoke a sense of the arabesque that was so important to the Symbolist Baudelaire and consequently to artists such as Gauguin and Matisse. The arabesque, as Baudelaire used it, symbolized philosophically the rhythms of the universe and was a conception of space and movement that emphasized sensations of form and space. O'Keeffe's emphasis on the rhythmic flowing washes was also seen in her more abstract series *Blue Nos. 1–4* (see pls. 1–4) where the arabesque was expressed in more abstract terms. As Matisse in his *Dance*, or Rodin in his drawings,

O'Keeffe in her nudes draws the viewer into a living space where a new sense of "self" or iden-tity, a new sense of the freedom and beauty of the human form, is born through emphasis on rhythm, musicality, and movement. One senses the presence of Isadora Duncan and her call for the freedom of the female form hovering in the background.

In 1917, O'Keeffe also created a series that evokes the human form in combination with nature, *Pink and Green Mountains Nos. 1–5* (see pls. 20 and 21). This group of paintings derived from a visit to the Rocky Mountains in 1917, during which O'Keeffe sketched in the Indian Peaks area near Ward, Colorado. The lush watercolors are and are not mountains,

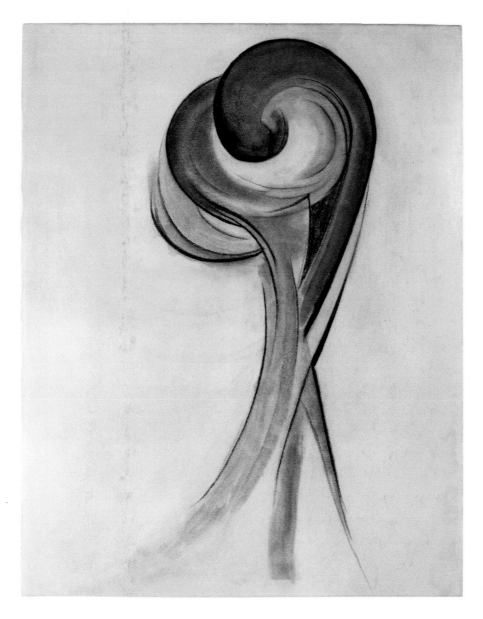

Figure 18. Georgia O'Keeffe, *Special No. 12*, 1917. Charcoal on paper, 24 x 19 in. The Museum of Modern Art, New York, gift of The Georgia O'Keeffe Foundation.

though, for they evoke the human form in a state of repose. A series done in the same year, *Evening Star* (pl. 26), which once again uses a spiral form, also contains suggestions of a reclining human form. In these series, as in some of the nudes, O'Keeffe seems to approach the "still point" of the dance. As T. S. Eliot writes in "Burnt Norton,"

> *At the still point of the turning world, neither flesh nor fleshless;*
> *Neither from nor towards; at the still point, there the dance is,*
> *But neither arrest nor movement. And do not call it fixity,*
> *Where the past and future are gathered. Neither movement from nor towards,*
> *Neither ascent nor decline. Except for the point, the still point,*
> *There would be no dance, and there is only the dance.*[47]

It is there, at the still point, as James Joyce described it, which is no "where," that "the supreme quality of beauty, the clear radiance of the esthetic image, is apprehended luminously by the mind which has been arrested by its wholeness and fascinated by its harmony . . . the luminous silent stasis of esthetic pleasure."[48]

The year 1919 brought further ambitious abstract paintings inspired by music or aural impressions. *Orange and Red Streak* recalls the dark emptiness of the Texas plains with a scarlet line of a new day. O'Keeffe later commented that this design was inspired by the sounds of the Texas Panhandle and that the jagged arc was inspired by the sounds of the cattle lowing musically in the night air. The songs of the cattle are also invoked in her *From the Plains I* (1919) where one once again finds jagged arc forms above the purple and blue tones of a night sky. Reinforcing the concept of the song imagery was O'Keeffe's inscription on the back of a photograph of the work: "A Song."

In 1919, O'Keeffe also painted two versions of *Music–Pink and Blue* (see pls. 5 and 6), whose central blue apertures are surrounded by pale, pastel organic folds. The compositions show some similarity to Pamela Colman Smith's work and illustrate O'Keeffe's wish for "real things . . . music that makes holes in the sky."[49] *Music–Pink and Blue No. 1*, commonly regarded as a pure abstraction, has also been seen as based on the enlarged segment of a shell,[50] thereby calling up the sounds of the sea and reinforcing the connections between the visual arts, music, and nature. The emphasis on the blue apertures and the gently vibrating forms surrounding the openings, recall Kandinsky's advocacy of the artist's expressing vibrations in the soul and that musical sound acts directly on the soul. As Kandinsky wrote, "Words, musical tones, and colors possess psychical power of calling forth soul vibrations. They create identical vibrations, ultimately bringing about the attainment of knowledge. . . ."[51]

The blue apertures and emphasis on a serene bodily sensation are found in later paintings, such as *Pelvis with Moon* (pl. 27), *Pelvis with Pedernal* (pl. 28), and *Pelvis II* (pl. 29). In *Pelvis with Moon*, for example, the bone dances elegantly across the canvas, almost ready

to take flight. Between 1943 and 1945, O'Keeffe did about a dozen canvases in the Pelvis series. The pelvis bone is explored from a variety of angles, as a whole and as a fragment, bringing a vibrant sense of life to a simple bone, which, for some, was a symbol of death. In the Pelvis paintings, the contrasts between the convex-concave surfaces and the positive-negative spaces accentuate the drama of performance. And the emphasis on the blue in the negative space, Kandinsky's heavenly blue, points to a world of infinity, beyond the concrete, everyday world. O'Keeffe wrote of these paintings:

> When I started painting the pelvis bones I was most interested in the holes in the bones—what I saw through them—particularly the blue from holding them up in the sun against the sky as one is apt to do when one seems to have more sky than the earth in one's world.
>
> They were most wonderful against the blue—that blue that will always be there as it is now after all man's destruction is finished.[52]

O'Keeffe's *Blue and Green Music* (see pl. 22) continues in a more pronounced fashion her exploration of vibration, conveying the harmonic pulsating of music or sound waves. Here, too, one finds the blue flamelike forms, suggesting dance as well. The large dark diagonal recalls her earlier drawings based on music. The wave motif is continued here and is used in subsequent paintings such as *A Celebration* (pl. 30), *Abstraction Blue* (1927), and *Abstraction, Alexis* (1928). In these later paintings, the wave forms have been transferred to sky and cloud imagery, reminding one also of Stieglitz's photographs in his series Songs of the Sky and Equivalents. In *A Celebration*, the dark blue rupture in the "clouds" recalls the thrusting diagonal of *Blue and Green Music* (see pl. 22). *Abstraction, Alexis* is a memorial for O'Keeffe's brother, Alexis, who was killed in the trenches during World War I by deadly clouds of gas. The musical or sound waves at the bottom of the canvas may be seen as song of mourning for her beloved brother.

The rhythmic elements of *Blue and Green Music* and the strong V composition were to surface in later paintings, particularly those that O'Keeffe did of her favorite "Black Place," a stretch of gray hills located about 150 miles northwest of Ghost Ranch in New Mexico. Between 1940 and 1949 O'Keeffe did a number of paintings of the Black Place, such as *Black Place Green* (pl. 31). The V shape seems to emphasize both dramatic and contemplative moods and provides a structure for the sense of opening that is evoked in the pieces.

O'Keeffe also completed a series of paintings in 1919, *Black Spot I, II*, and *III*, that explore musical motifs begun in some of the early drawings such as *Black Lines (Abstraction)* (see fig. 17) and evidence some influence of Picabia's fluid biomorphic shapes. The subtle variations in color and shape that O'Keeffe employs from canvas to canvas can well be compared to a theme and variations in musical and dance pieces.

A number of O'Keeffe's flower paintings from the 1920s, although flowers, also include motifs from the earlier musical pieces. One finds, for example, in her rose images such as *White Rose with Larkspur No. 2* (pl. 32) or *Abstraction, White Rose No. 2* (see pl. 23) the curvilinear spiral element. The spiral draws us deep into the flower, to some "place" or space beyond the flower where the elements of music and dance draw us in. In *White Rose with Larkspur No. 2*, the white rose is reborn, representing a world of delicate sensitivity as it is gently embraced by the blue and purple tones of the protective larkspur. With the rose, the viewer may be reborn to experience new sensations. In *Abstraction, White Rose No. 3* (see pl. 24), O'Keeffe abstracted the rose petals to curvilinear bands of white light, emanating from a mysterious center—a glistening pearl shape. The glistening shape and sense of mystery remind one of the exotic dances of Loïe Fuller in which she used light, sound, and color to create her flower and flame dances.

In an earlier flower painting, *Flower Abstraction* (see pl. 25), one finds the biomorphic forms of Picabia's dance pieces, as well as the dominating V structure that was so important in *Blue and Green Music* (see pl. 22). Or in *Dark Iris No. 2* (1926), one finds the sinuous forms suggestive of a human torso, flowing gently into the "flower form." The carefully modeled waves of pinks and grays point to a music for the body and the soul. Thus, in a number of flower paintings, particularly the more abstract ones, nature, the human form, and musical "sensations" become intertwined through abstraction. Such images perhaps probe more deeply into the soul of nature, or our own souls, than concrete or mimetic images could. The spiral motif was also to appear in numerous other paintings, such as her shell paintings, e.g., *Shell I* (1928), *Nature Forms, Gaspé* (1932), and *Goat's Horn with Red* (1945).

O'Keeffe also used the spiral form in her sculpture. In 1945, she created a sensuous white smoothly modeled large-scale sculpture. The sensuous shapes and smoothly modeled edges are reminiscent of her paintings. At age ninety-four, O'Keeffe completed an even larger scale spiral piece, *Abstraction* (fig. 19). The eleven-foot painted cast-aluminum piece spoke to O'Keeffe's ability to explore and refine specific motifs such as the spiral, throughout her career.

To return to other pieces that have their roots in dance imagery, a number of O'Keeffe's paintings of trees emphasize gesture and movement in a manner that goes far beyond the image of the tree. Isadora Duncan's daughter, Marie Theresa, once wrote, "To speak or to dance with the perfect rectitude and insouciance of the movement of animals and the unimpeachableness of the sentiments of trees in the woods and grass, is the flawless triumph of art."[53] In seeming agreement with this philosophy, O'Keeffe's paintings of trees celebrate freedom of movement, gesture, and form. Once again, these paintings are and are not trees, for the vitality of dance and the vitality of nature are captured in their graceful forms. O'Keeffe began her tree paintings in the 1920s but continued her interest in gestural forms into the 1950s, in both paintings and drawings. In a piece such as *Autumn Trees–The Maple* (pl. 33),

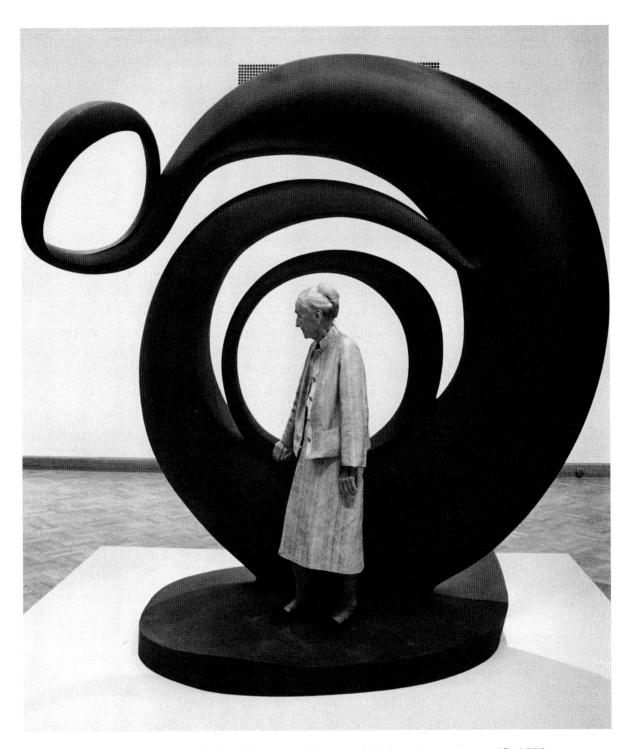

Figure 19. Georgia O'Keeffe at the San Francisco Museum of Modern Art on August 15, 1982 with her sculptural piece *Abstraction* (aluminum, 1980).

one also sees an affinity with Synchromist paintings with their emphasis on color, form, and musical harmony.

Both O'Keeffe and Stieglitz were interested in the nuances and movements of nature's forms. Stieglitz actually titled one of his photographs of 1922 *Dancing Trees* (fig. 20). As in some of O'Keeffe's paintings, he has cropped the tree to concentrate on the movement of the limbs—and one finds words referring to the music of the trees, such as those written by Stieglitz to his friend and assistant, Marie Rapp, "and the rustle of the leaves, swaying branches—great music."[54] Stieglitz had also been inspired by the work of Charles Demuth, who had done a series of abstract designs based on tree limbs in the mid-1910s.

The trees seem to take on an anthropomorphic quality for O'Keeffe and Stieglitz. Both mourned the death of a large old chestnut tree, Stieglitz's favorite on his mother's Lake George property, through paintings and photographs of the dead chestnut silhouetted against the sky. Thus in nature's forms, as in the trees, the artists found analogues for inner states of mind. One of O'Keeffe's tree paintings, *Birch and Pine Trees, Pink* (1925), is believed to be a surrogate portrait of her friend, the writer Jean Toomer, who came to Lake George in 1925. Although the other tree paintings do not necessarily allude to specific individuals, it is easy to see in them an affinity with the human form and the rhythmic gestures of modern dance, in particular some of the emphasis on linear elements found in Martha Graham's choreography. Thus, paintings such as *Gray Tree–Lake George* (1922) (pl. 34), *White Birch, Lake George* (1926), *Red Maple* (1927), and *Gray Tree by the Road* (1952) (pl. 35) draw us into the dance of nature, or the dance of life, as Nietzsche described life's course.

In some of O'Keeffe's tree paintings, "the dance" and the dancer seem to become one as foreground and background are united through the flowing forms and colors. Some of her paintings might respond well to William Butler Yeats's lines,

> *O chestnut tree, great rooted blossomer,*
> *Are you the leaf, the blossom, or the bole?*
> *O body swayed to music, O brightening glance,*
> *How can we know the dancer from the dance?*[55]

As Yeats's tree has become one with its surroundings, its "body swayed to music," so, too, do some of O'Keeffe's trees. In *Red Maple*, for instance, the brilliance of the red, yellow, orange, and green foliage, the rhythmic gray limbs, and the intensity of the blue sky are united as the "dancer" and the dance seem to become one.

The emphasis on unity, harmony, and inspiration from nature found in O'Keeffe's work has clear connections to Isadora Duncan's philosophy. In an essay entitled "The Dancer and Nature," Duncan wrote

Figure 20. Alfred Stieglitz,
Dancing Trees, 1922.
Palladium print, 10 x 8 in.
Museum of Fine Arts,
Boston, Alfred Stieglitz
Collection (24.1734),
gift of Alfred Stieglitz.

Woman is not a thing apart and separate from all other life organic and inorganic.
She is but a link in the chain, and her movement must be one with the great move-
ment which runs through the universe; and therefore the fountainhead for the art of
dance will be the study of the movements of nature.[56]

Duncan saw art and dance as originating in the patterns of nature that included a wave movement running through all natural phenomena, including the human body. O'Keeffe and her work may be seen as links in the chain that Duncan describes.

That the tree and other O'Keeffe paintings may be linked with dance forms, yet have no distinct individual, human reference point, also makes it possible for the viewer to move more

easily toward a universalized art of abstract harmonies and gestures. Many of these pieces may well encompass "the fourth dimension," which may also be described as "a suggestion motion which appears for an instant, and then loses itself in the unending succession of its variations . . . a halo enveloping essence and action, uniting the visible with the invisible, responding to both relative and absolute motions, integrating objects with their milieu."[57]

The gestural language of the tree paintings is carried further in some of O'Keeffe's later desert skull paintings, where the antlers and the skulls appear to dance in the sky above the New Mexican landscape, for example, *Ram's Head with Hollyhock* (1935), *Summer Days* (1936), and *From the Far Away Nearby* (pl. 36). Once again, life is given to dead forms. In *From the Far Away Nearby*, the subtle soft tones of blue, pink, gray, and brown work together to form a powerful statement about nature, life cycles, and desert life. Much of the power of the painting lies in the graceful upward sweep of the antlers. The antler forms seem to come alive, carefully modeled and delineated against the softness of the pale pink and blue sky. The reversed arc forms of the mountains below—the stage, in this instance—provide a counterbalance to the upward thrust of the antlers.

Some of O'Keeffe's pieces, rather than containing gestural forms, imply, through the objects depicted, an understanding and appreciation of dance and music as related to ritual. One finds, for instance, that in her *Mask with Golden Apple* (1924), the African mask and golden apple in combination suggest rites related to creation or fertility. Her 1936 *Kachina* with its feathers and painted face speaks of ritual as well. The objects are clearly from cultures that have valued music and dance as an integral part of everyday life.

Some of O'Keeffe's series, although not always containing specific references to music and dance elements in each piece, may refer to concepts of metamorphosis and transformation that were inherent in the work of dancers such as Loïe Fuller and Isadora Duncan. For instance, there is the Jack in the Pulpit series, consisting of six paintings done in 1936, where O'Keeffe transforms the initial image from a fairly realistic representation to a final abstraction. *Number 5* perhaps contains the most movement. The flowing tendril-like forms that appear in many of O'Keeffe's paintings, along with the powerful purples and greens, add a dynamic sense of rhythm and movement to this painting. In *Number 6*, the black pistil of the flower with its white halo has a striking religious and mystical appearance. One finds the same metamorphosis in an earlier, smaller set of seven images that progress from realistic to abstract, the Shell and Old Clam Shell series of 1926. The shell and old shingle appear to be on a "stage set," dancing toward abstraction.

O'Keeffe continued to celebrate the power of music and dance in her work throughout much of her career. By her nineties, her watercolors, such as *Red Line with Circle* (1977), *Curved Lines with Rounded Spots Blue* (1977), and *Like an Early Blue Abstraction* (pl. 37),

resemble some of her abstract works of 1916–19. And besides the large spiral sculpture, O'Keeffe turned to making clay pots with the assistance of Juan Hamilton. The smooth clay surfaces and shapes resemble O'Keeffe's rock paintings based on rocks she had found in the New Mexican landscape. The pots and the rock paintings may be likened to the notes on a musical scale, singing forth clearly the songs of the desert and the clay. In a sense, O'Keeffe had come full circle, returning to the simplified, elemental forms of her youth.

In general, O'Keeffe's evocation of music and dance in her visual works may be seen to represent a synthesis of the Apollonian and Dionysian worlds that Nietzsche describes in his *The Birth of Tragedy*. O'Keeffe's carefully articulated, beautiful colors and forms, which can be related to the Apollonian, guide and accompany us in experiencing a more sensual, Dionysian world. Through this synthesis one can attempt to experience the higher reality of music and dance that Nietzsche refers to: "In song and in dance man expresses himself as a member of a higher community."[58] And like Nietzsche's dancer, O'Keeffe's work achieves rhythmic freedom and harmony in the shadows of contemporary dilemmas.

In representing the intersections of the visual arts, music, and dance, O'Keeffe allows for spatial and temporal elements to interact, calling to a variety of the viewer's senses and providing for a more complete interaction with the work. If one begins to understand the role of music and dance in O'Keeffe's work, it is easy to see that her work goes far beyond the sexual symbolism that some critics have attributed to it. She creates a new reality that surpasses our material world. For as the writer Lee Nordness has observed,

> *The great problems of our period are not material ones; they are problems of basic relationships. . . . In itself space may be benign and all-embracing, but the way in which man is exploiting his . . . ability to enter it and explore it, is perilous. It results in a feeling that it is first of all necessary and inevitable for the artist to express whatever inner vitality he possesses and that a new aesthetic must be created to formulate new conceptions of space, light, movement, and infinity.*[59]

O'Keeffe's aesthetic has provided new formulations of space, color, light, form, and movement that push us toward infinity. This aesthetic, which has significant roots in music and dance, still speaks to us today, strongly, directly, and honestly. Her work calls for us to celebrate the power of music and dance in combination with the visual arts. And her work calls for us to participate, to have a new sense of ourselves, to move and be moved, "surrounded/By a grace of sense, a white light still and moving . . ."[60]

Notes

1. William Murrell Fisher, "The Georgia O'Keeffe Drawings and Paintings at 291," *Camera Work* 49–50 (June 1917): 5.

2. Lewis Mumford, "O'Keeffe and Matisse," *New Republic* 50 (2 March 1927): 41.

3. Georgia O'Keeffe, quoted in "'I Can't Sing So I Paint!' Says Ultra Realistic Artist; Art is Not Photography— It is Expression of Inner Life!: Miss Georgia O'Keeffe Explains Subjective Aspect of Her Work," *New York Sun* (December 5, 1922): 22.

4. Luna May Ellis, *Music in Art* (Boston: L. C. Page and Company, 1904), v.

5. Wassily Kandinsky, *Concerning the Spiritual in Art* (1912), trans. M. T. H. Sadler in 1914 under the title *The Art of Spiritual Harmony* (New York: Dover Publications, 1977), 51.

6. Dore Ashton, *A Reading of Modern Art* (New York: Harper and Row, 1971), 152.

7. Johann Christoph Friedrich von Schiller, "Ode to Joy," trans. Brother Andrew Thornton in *Readings in the Humanities*, St. Anselm College Second Year Program (Acton, Mass.: Copley Custom Publishing Group, 1955), 338–39.

8. Isidore of Seville, quoted in E. M. W. Tillyard, "The Cosmic Dance," in *What is Dance? Readings in Theory and Criticism*, ed. Roger Copeland and Marshall Cohen (New York: Oxford University Press, 1983), 497.

9. René Descartes, *Abrégé de musique*, pp. 135–36, quoted in Downing A. Thomas, *Music and the Origins of Language, Theories of the French Enlightenment* (New York: Cambridge University Press, 1985), 28.

10. Friedrich Nietzsche, *Thus Spake Zarathustra* (1883–91), in *The Portable Nietzsche*, comp. and trans. Walter Kaufmann (New York: Viking Press, 1968), 153.

11. Ernst Mach, quoted in Yves Kobry, "The Depths of the Ego," in *Symbolist Europe—Lost Paradise* (Montreal: Musée des Beaux-Arts, 1995), 46.

12. For further discussion of Mallarmé's aesthetic theories, and his *Divagations*, see A. G. Lehmann, *The Symbolist Aesthetic in France, 1885–1895* (Oxford: Basil Blackwell, 1950).

13. Stéphane Mallarmé, quoted in *Mallarmé: Selected Prose Poems, Essays, and Letters*, trans. and intro. Bradford Cook (Baltimore: Johns Hopkins University Press, 1953), 43–56.

14. Arthur Wesley Dow, *Composition: A Series of Exercises in Art Structure for the Use of Students and Teachers* (New York: Doubleday, Page, 1912), 5.

15. Alfred Stieglitz, quoted in Dorothy Norman, *Alfred Stieglitz: An American Seer* (New York: Random House, 1973), 161.

16. Alfred Stieglitz, letter to Hart Crane, September 1923, quoted in Sarah Greenough and Juan Hamilton, *Alfred Stieglitz, Photographs and Writings* (Washington, D.C.: National Gallery of Art, 1983), 207.

17. Paul Rosenfeld, "The Paintings of Georgia O'Keeffe: The Work of the Young Artist Whose Canvases are to be Exhibited in Bulk for the First Time This Winter," *Vanity Fair* 19 (October 1922): 56, 112, 114.

18. Herbert Seligmann, "Georgia O'Keeffe, American," *Mss.* 5 (March 1923): 10.

19. Herbert Seligmann, "Why Modern Art: Six Artists in Search of Media for their Variously Capricious Spirits Demonstrate that 'Modern' Art is not Merely Contemporary Art," *Vogue* 62 (15 October 1923): 112.

20. Wassily Kandinsky, op. cit., 25.

21. Ibid., 38.

22. Eddy had written an entire book on Whistler in 1903—*Recollections and Impressions of James A. McNeill Whistler*. There he quoted Whistler's "The Gentle Art of Making Enemies." "As Music is the poetry of sound, so is painting the poetry of sight and the subject matter has nothing to do with the harmony or sound of color" (p. 179). Eddy went on to write that "there is a music for color even as there is a music of sound. . . ." (p. 183). It is unclear whether O'Keeffe read the 1903 book, but she and Stieglitz undoubtedly knew of Whistler's works. While O'Keeffe was in New York, the Macbeth Gallery mounted a show in 1908 including Whistler, and by 1914 The Metropolitan Museum of Art owned six Whistlers—four portraits and two nocturnal paintings.

23. Arthur Jerome Eddy, *Cubists and Post-Impressionism* (Chicago: A. C. McClurg & Co., 1914), 220.

24. Isadora Duncan, quoted in Floyd Dell, *Women as World Builders* (Chicago: Forbes and Co., 1913), 49–50.

25. Willard Huntington Wright, *The Creative Will* (New York: John Lane Company, 1916), 105.

26. Ibid., 11.

27. Marius de Zayas, *African Negro Art: Its Influence on Modern Art* (New York: Modern Gallery, 1916), 41.

28. Mary Lynn Kotz, "A Day with Georgia O'Keeffe," *ArtNews* (December 1977): 44.

29. Stéphane Mallarmé, op. cit., 43–56.

30. Lewis Mumford, "O'Keeffe and Matisse," *New Republic* 50 (2 March 1927): 42.

31. Friedrich Nietzsche, *The Birth of Tragedy* (1872), trans. Clifton Fadiman in *The Philosophy of Nietzsche* (New York: The Modern Library, 1954), 956.

32. Hugo von Hofmannsthal, quoted in Walter Sorell, *Dance in Its Time* (New York: Anchor Press/Doubleday, 1981), 335.

33. Ibid., 337.

34. Ibid., 336.

35. Paul Valéry, quoted in ibid., 341.

36. Ibid.

37. Mark Franko, *Dancing Modernism/Performing Politics* (Bloomington and Indianapolis: Indiana University Press, 1995), 43.

38. Elizabeth Kendall, *Where She Danced* (Berkeley: University of California Press, 1979), 123.

39. Francis Picabia, quoted in Hutchins Hapgood, "A Paris Painter," *New York Globe and Commercial Advertiser* (Feb. 20, 1913): 12.

40. Francis Picabia, quoted in Arthur Jerome Eddy, op. cit., 96–97.

41. Oscar Bluemner, diary, 4 July 1925, Archives of American Art/Smithsonian Institution, microfilm roll 340, frames 1516–19.

42. Oscar Bluemner, diary, 5 May 1927, Archives of American Art/Smithsonian Institution (340:1745).

43. Arthur Dove, letter to Bluemner, 22 March 1928, John David Hatch Papers, Archives of American Art, Smithsonian Institution.

44. Georgia O'Keeffe, letter to Anita Pollitzer, June 1915, in Jack Cowart and Juan Hamilton, *Georgia O'Keeffe: Arts and Letters* (Washington, D.C.: National Gallery of Art, 1987), 142.

45. Georgia O'Keeffe, letter to Anita Pollitzer, January 4, 1916, op. cit., 148.

46. Belinda Rathbone, "Like Nature Itself," in *Georgia O'Keeffe and Alfred Stieglitz—Two Lives* (New York: Harper Collins, 1992), 53.

47. T. S. Eliot, "Burnt Norton," in *Four Quartets* (New York: Harcourt Brace and World, 1943), 15–16.

48. James Joyce, *A Portrait of the Artist as a Young Man* (London: Jonathan Cape, Ltd., 1916), 242.

49. Georgia O'Keeffe, letter to Anita Pollitzer, January 14, 1916, op. cit., 149.

50. Sarah Whitaker Peters, *Becoming O'Keeffe* (New York: Abbeville Press, 1991), 228.

51. Wassily Kandinsky, op. cit., 29.

52. Georgia O'Keeffe, "About Painting Desert Bones" (1943), quoted in Lloyd Goodrich and Doris Bry, *Georgia O'Keeffe* (New York: Whitney Museum of American Art, 1970), 25.

53. Marie Theresa, "Isadora, the Artist, Daughter of Prometheus," introduction to *Isadora Duncan in Her Dances by Abraham Walkowitz* (Girard, Kansas: Haldeman-Julius Publications, 1945), 3.

54. Alfred Stieglitz, letter to Marie Rapp, August 26, 1916, Yale Collection of American Literatue, New Haven, Conn.

55. William Butler Yeats, "Among School Children," in *The New Oxford Book of English Verse, 1250–1950*, ed. Helen Gardner (New York: Oxford University Press, 1972), 826.

56. Isadora Duncan, "The Dancer and Nature," quoted in Rachel Vigier, *Gestures of Genius* (New York: The Mercury Press, 1989), 47.

57. Umberto Boccioni, quoted in Rosa Trillo Clough, *Futurism, The Story of Modern Art Movement* (New York: Philosophical Library, 1961), 87.

58. Friedrich Nietzsche, *The Birth of Tragedy*, op. cit., 501.

59. Lee Nordness, *Art: U.S.A.: Now* (New York: Viking Press, 1963), 12–14.

60. T. S. Eliot, op. cit., 16.

PLATES

Plate 1. *Blue No. 1.*
1916, watercolor on tissue paper, 16 x 11 in.
The Brooklyn Museum of Art, New York (58.73),
bequest of Mary T. Cockcroft.

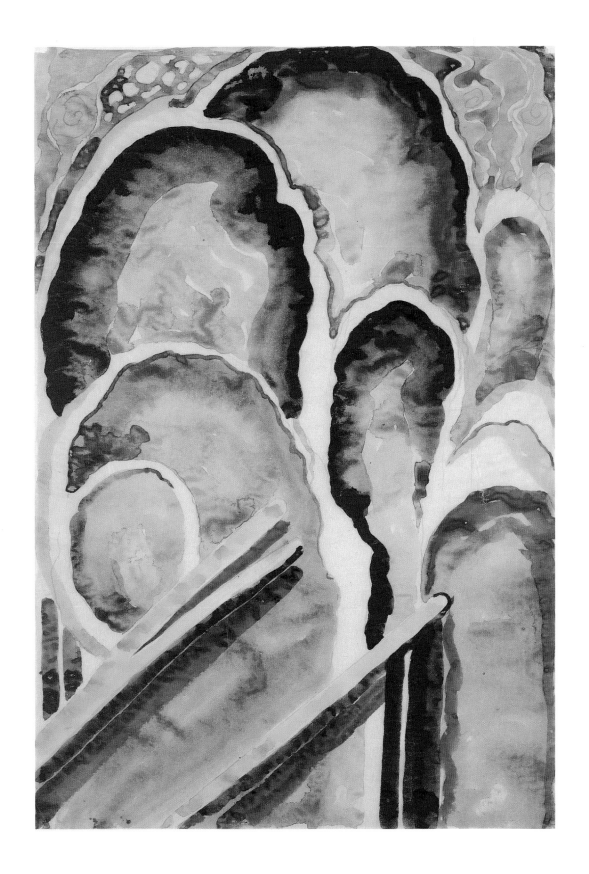

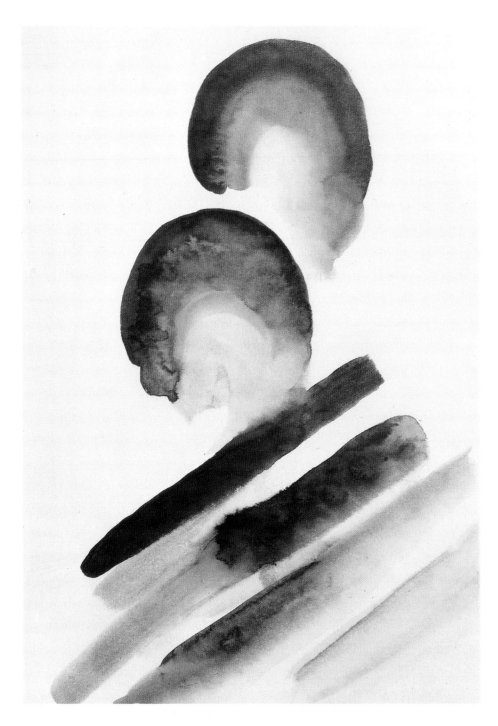

Plate 2. *Blue No. 2.*
1916, watercolor on tissue paper, 15 $\frac{7}{8}$ x 10 $\frac{15}{16}$ in.
The Brooklyn Museum of Art, New York (58.74),
bequest of Mary T. Cockcroft.

Plate 3. *Blue No. 3.*
1916, watercolor on tissue paper, 15 $\frac{7}{8}$ x 10 $\frac{15}{16}$ in.
The Brooklyn Museum of Art, New York (58.75),
Dick S. Ramsay Fund.

Plate 4. *Blue No. 4.*
1916, watercolor on tissue paper, 15 15/16 x 10 15/16 in.
The Brooklyn Museum of Art, New York (58.76),
Dick S. Ramsay Fund.

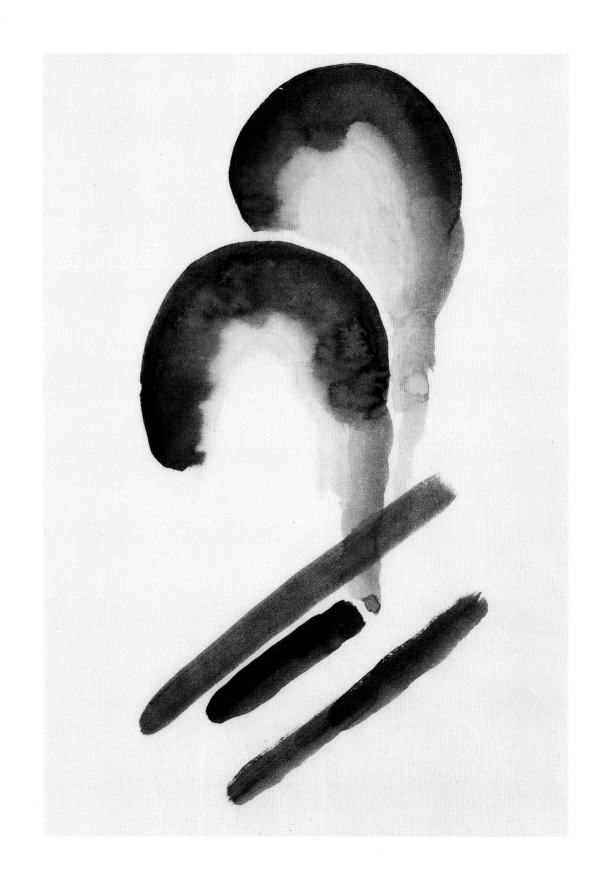

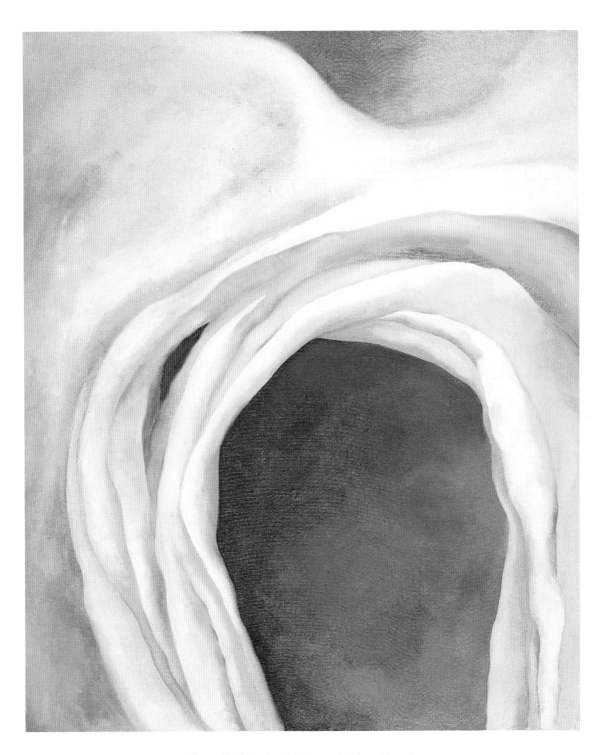

Plate 5. *Music–Pink and Blue No. 1*.
1919, oil on canvas, 35 x 29 in.
Collection of Mr. and Mrs. Barney A. Ebsworth.

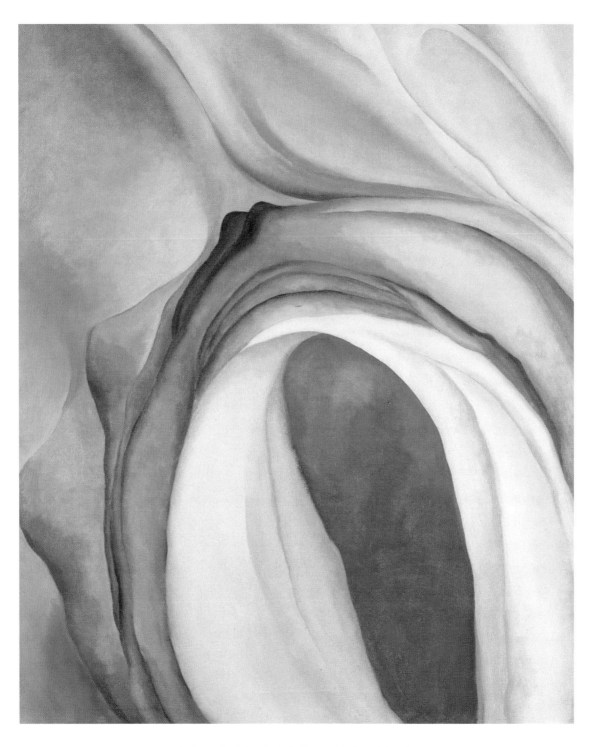

Plate 6. *Music–Pink and Blue No. 2.*
1919, oil on canvas, 35 x 29 ⅛ in. Whitney Museum of American Art, New York (91.90),
gift of Emily Fisher Landau in honor of Tom Armstrong.

Plate 7. *Blue Nude.*
c. 1917, watercolor on paper, 15 1/16 x 11 1/8 in.
Sheldon Memorial Art Gallery,
University of Nebraska-Lincoln (1991.U-4423),
anonymous donor.

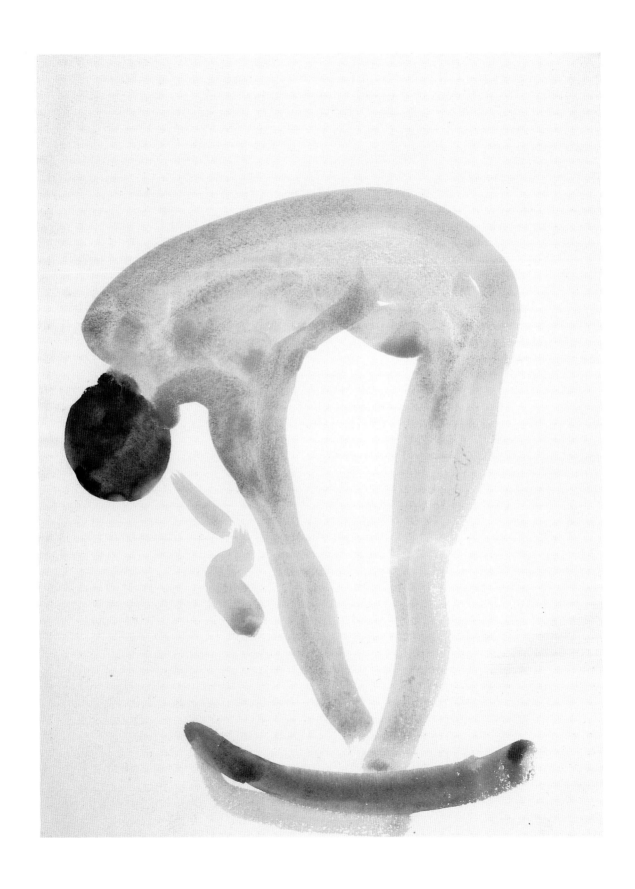

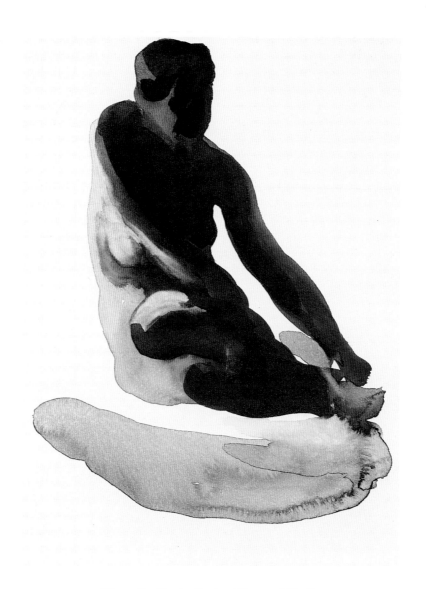

Plate 8. *Nude Series (Seated Red).*
c. 1917, watercolor on paper, 12 x 9 in.
© The Georgia O'Keeffe Museum, Santa Fe,
gift of The Burnett Foundation
and The Georgia O'Keeffe Foundation.

opposite:

Plate 9. *Nude Series I.*
1917, watercolor on paper, 12 x 9 in.
Collection of The Georgia O'Keeffe Foundation.

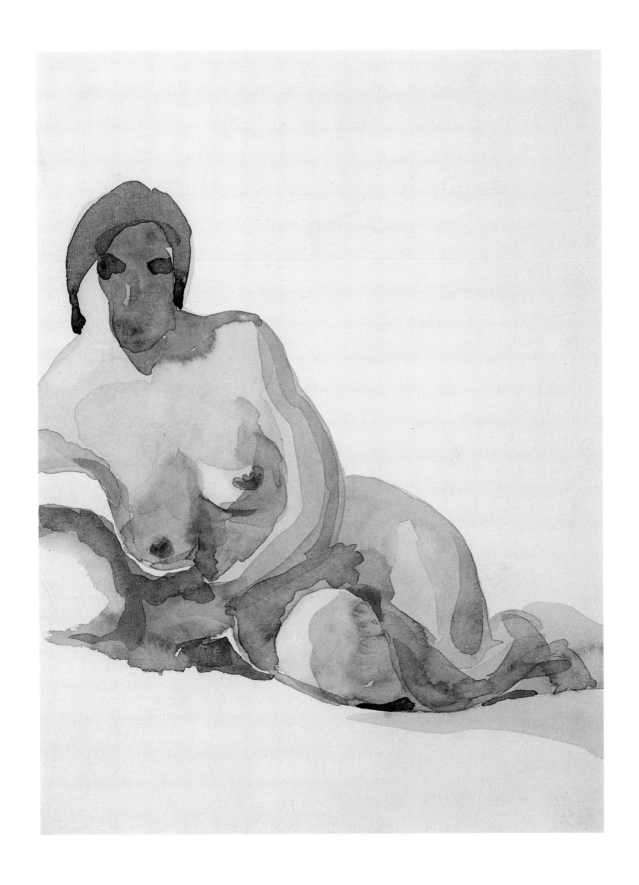

Plate 10. *Nude Series II*.
1917, watercolor on paper, 12 x 9 in.
Collection of The Georgia O'Keeffe Foundation.

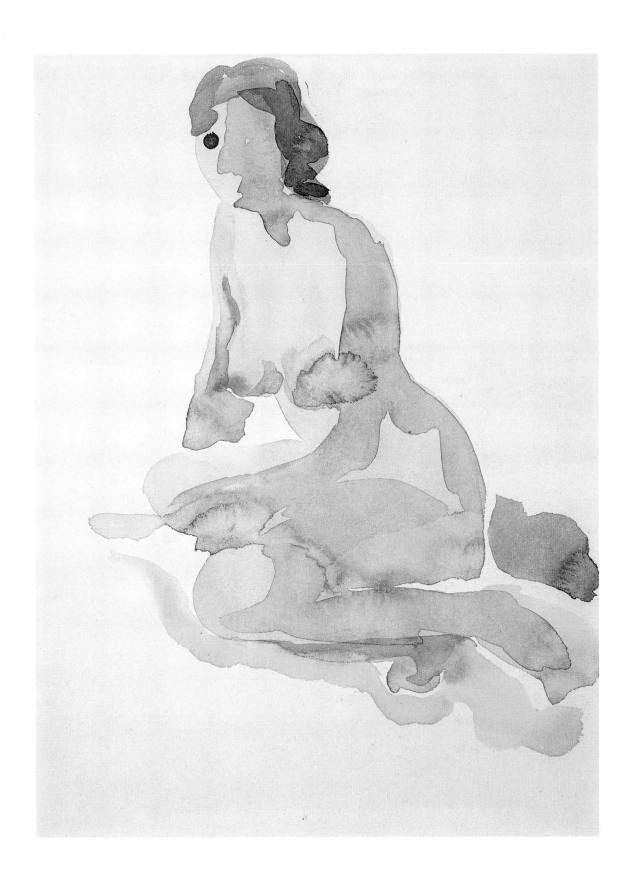

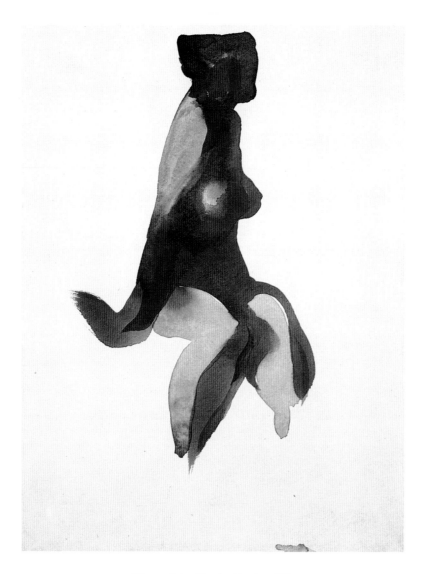

Plate 11. *Nude Series III*.
1917, watercolor on paperboard, 12 x 8 7/8 in.
National Gallery of Art, Washington D.C. (1996.46.1.[DR]),
gift of Joan and Lucio Noto
and The Georgia O'Keeffe Foundation.

opposite:

Plate 12. *Nude Series IV*.
1917, watercolor on paper, 12 x 9 in.
Private collection.

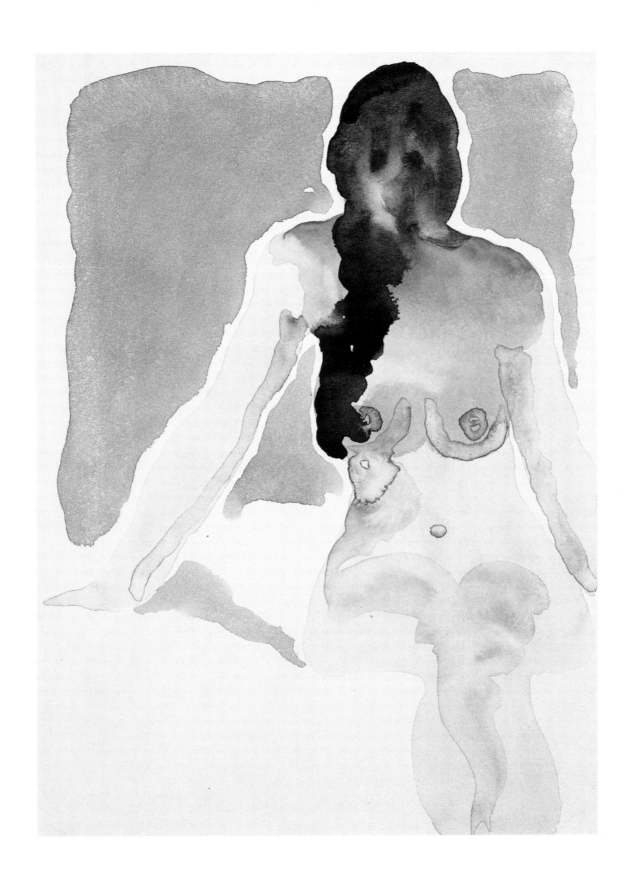

Plate 13. *Nude Series VI.*
1917, watercolor on paper, 12 x 9 in.
Collection of The Georgia O'Keeffe Foundation.

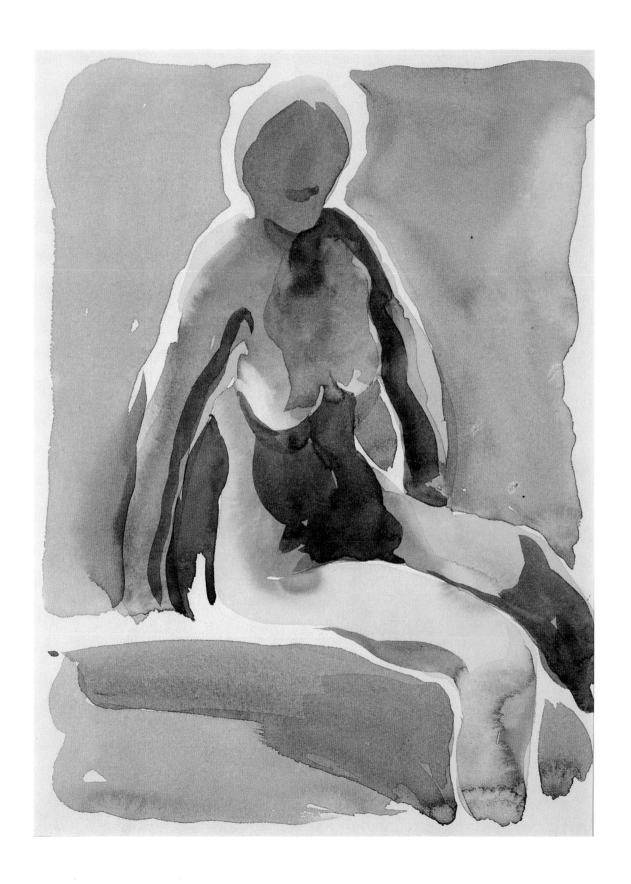

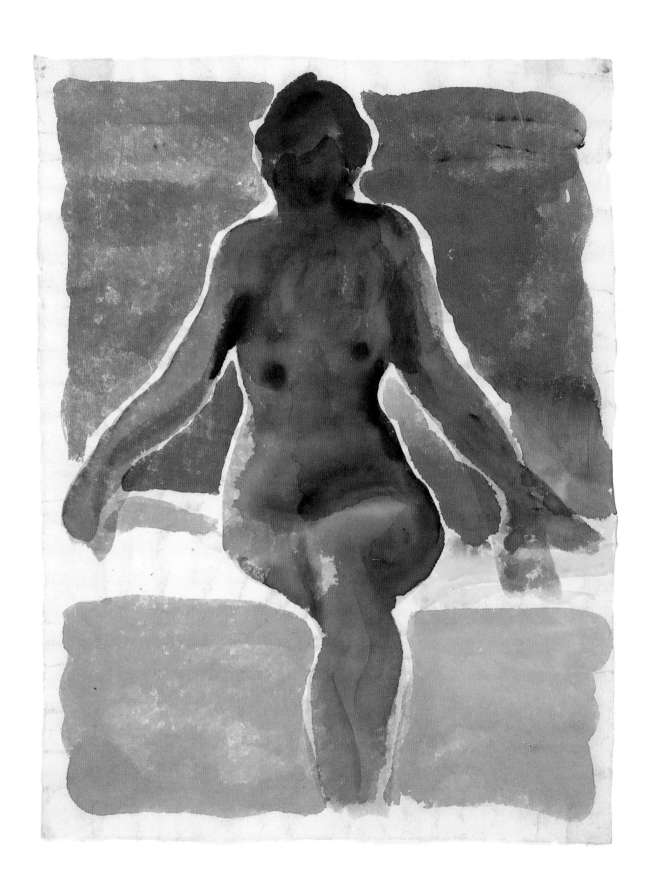

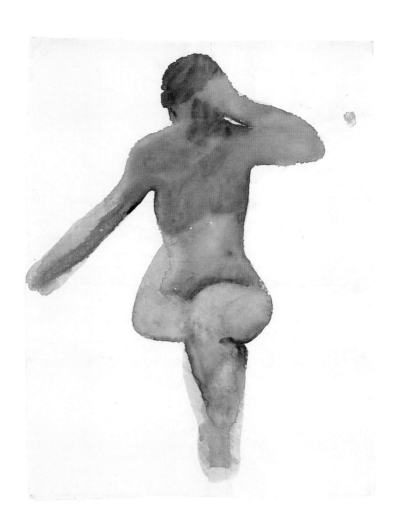

Plate 15. *Nude Series VIII*.
1917, watercolor on paper, 18 x 13 ¹/₂ in.
© The Georgia O'Keeffe Museum, Santa Fe,
gift of The Burnett Foundation
and The Georgia O'Keeffe Foundation.

opposite:

Plate 14. *Nude Series VII*.
1917, watercolor on paper, 17 ³/₄ x 13 ¹/₂ in.
© The Georgia O'Keeffe Museum, Santa Fe,
gift of The Burnett Foundation
and The Georgia O'Keeffe Foundation.

Plate 16. *Nude Series IX.*
1917, watercolor on paper, 12 x 8 7/8 in.
Collection of The Georgia O'Keeffe Foundation.

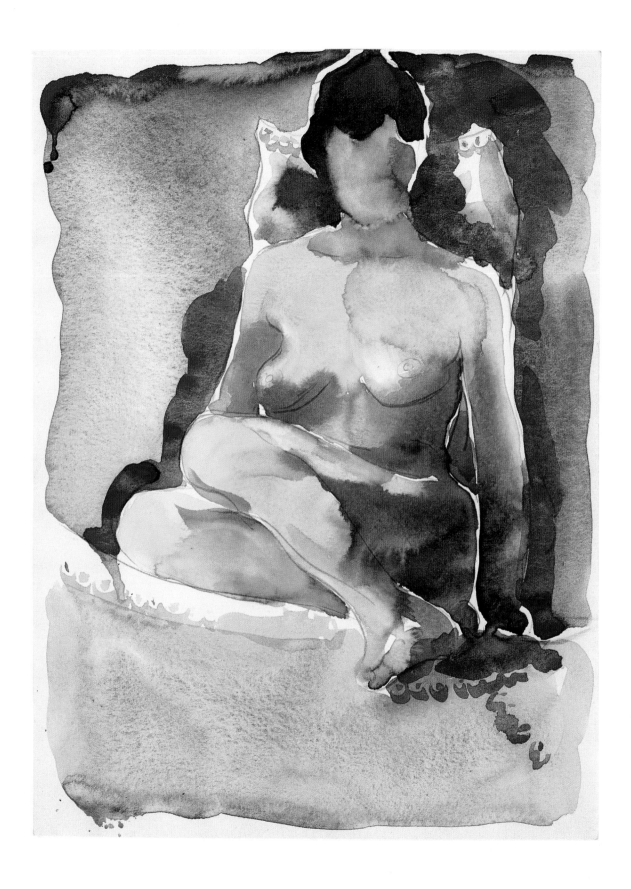

Plate 17. *Seated Nude X.*
1917, watercolor on paper, 11 $\frac{7}{8}$ x 8 $\frac{7}{8}$ in.
The Metropolitan Museum of Art, New York (1981.324),
Van Day Truex Fund, 1981.

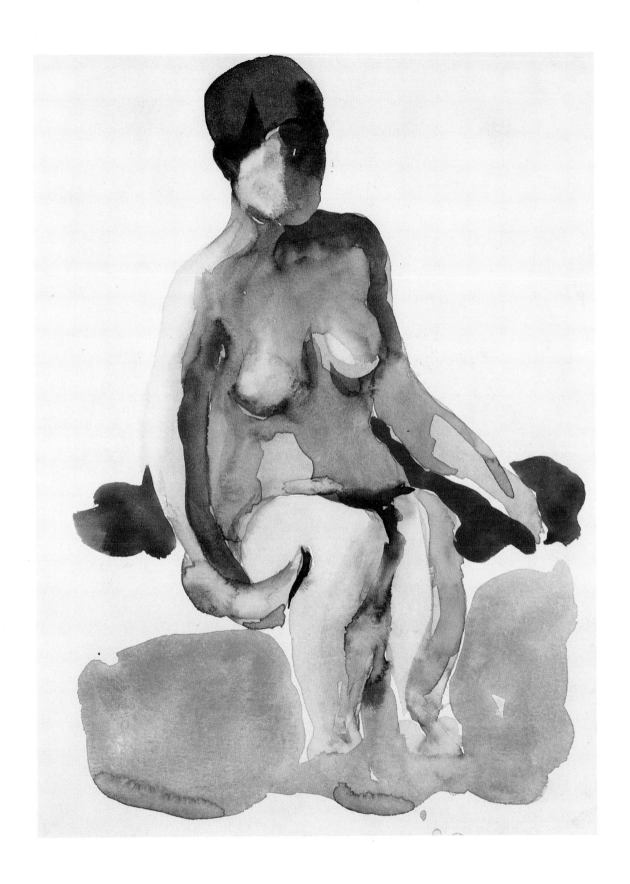

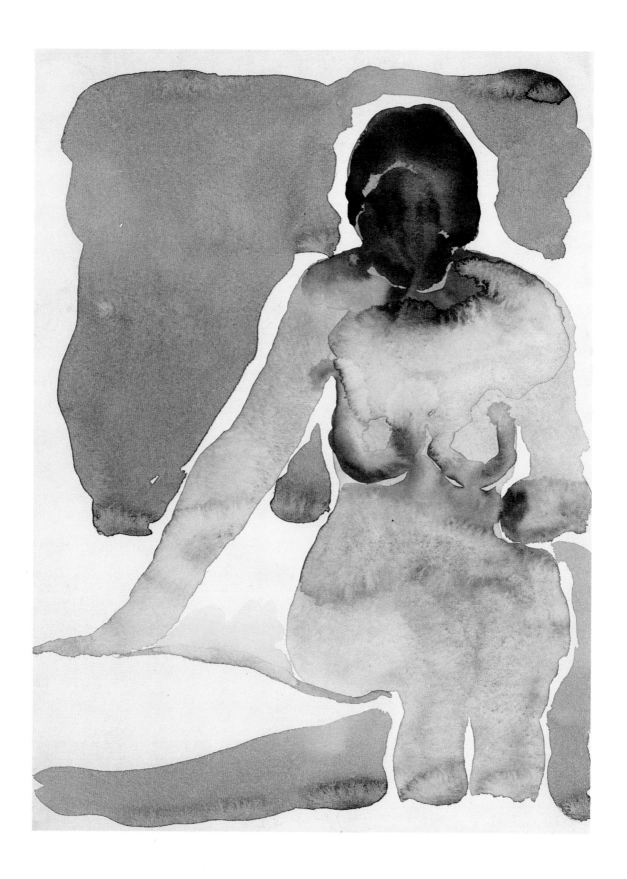

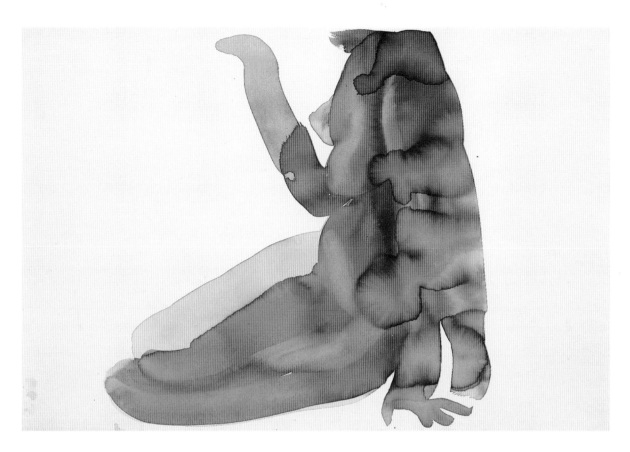

Plate 19. *Nude Series XII.*
1917, watercolor on paper, 12 x 18 in.
© The Georgia O'Keeffe Museum, Santa Fe,
gift of The Burnett Foundation
and The Georgia O'Keeffe Foundation.

opposite:

Plate 18. *Seated Nude XI.*
1917, watercolor on paper, 11 $\frac{7}{8}$ x 8 $\frac{7}{8}$ in.
The Metropolitan Museum of Art, New York (1981.194),
purchase, Mr. and Mrs. Milton Petrie Gift, 1981.

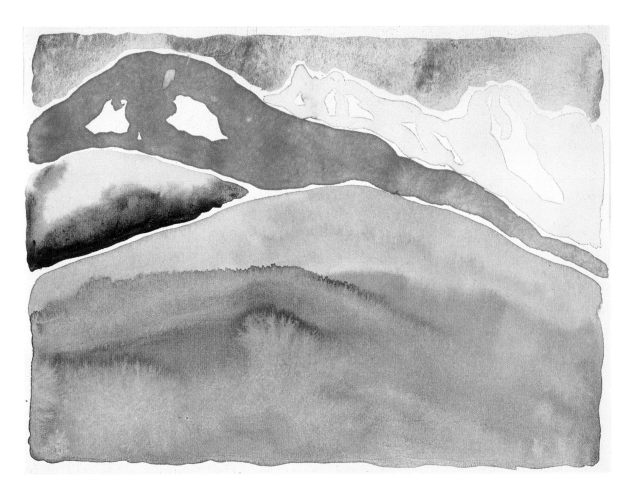

Plate 20. *Pink and Green Mountains No. 1*.
1917, watercolor, 9 x 12 in.
Spencer Museum of Art, The University of Kansas (77.43),
Letha Churchill Walker Fund.

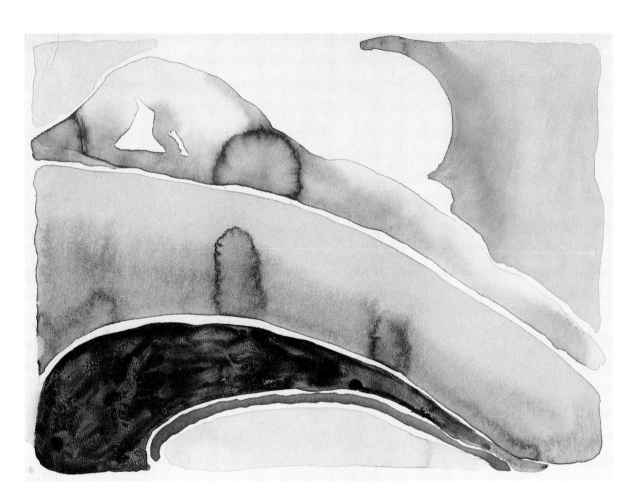

Plate 21. *Pink and Green Mountains No. 3.*
1917, watercolor on paper, 8 7/8 x 11 7/8 in.
Milwaukee Art Museum (M1977.129),
gift of Mrs. Harry Lynde Bradley.

Plate 22. *Blue and Green Music*.
1919, oil on canvas, 23 x 19 in.
The Art Institute of Chicago, Alfred Stieglitz Collection (1969.835),
gift of Georgia O'Keeffe.

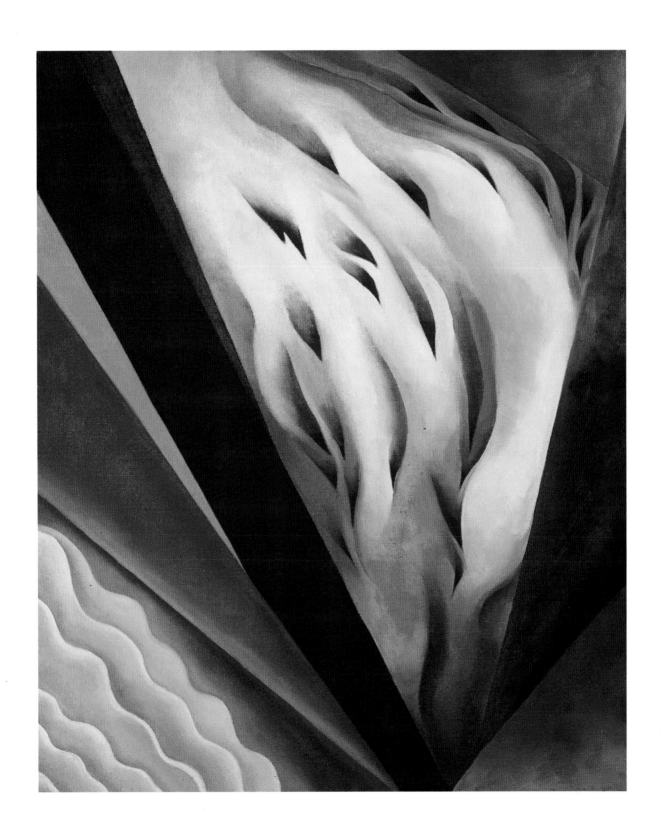

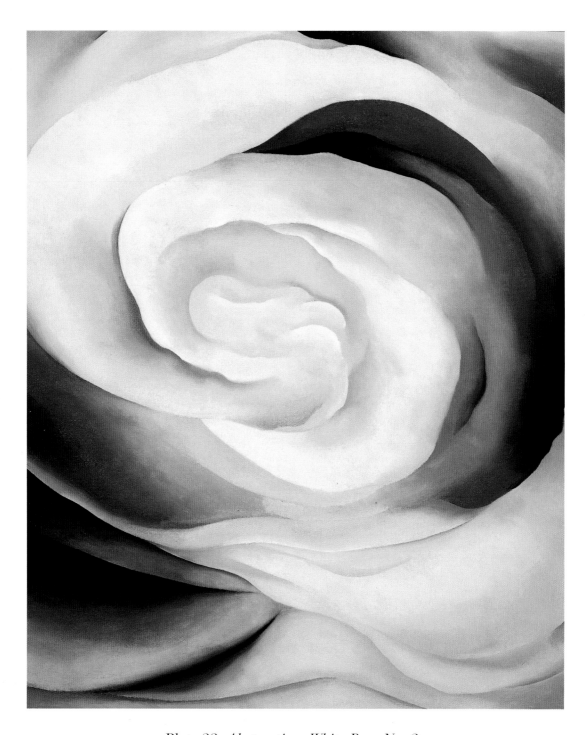

Plate 23. *Abstraction, White Rose No. 2.*
1927, oil on canvas, 36 ¼ x 30 in.
© The Georgia O'Keeffe Museum, Santa Fe,
gift of The Burnett Foundation and The Georgia O'Keeffe Foundation.

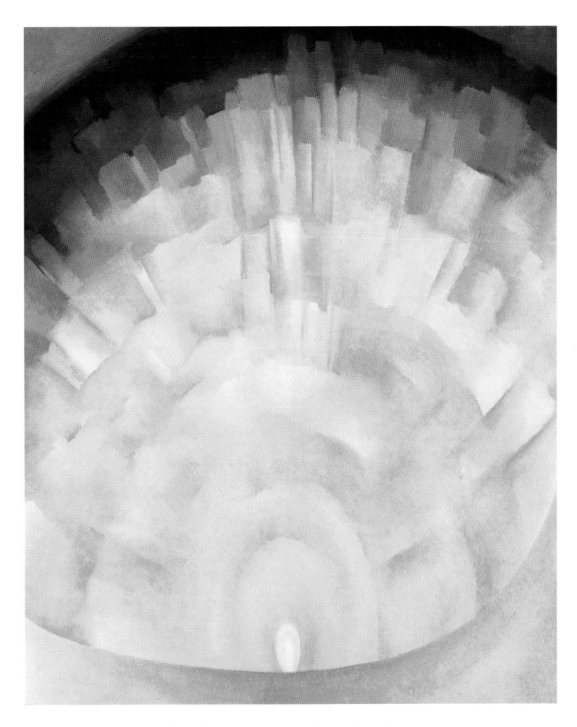

Plate 24. *Abstraction, White Rose No. 3.*
1927, oil on canvas, 36 x 30 in.
The Art Institute of Chicago, Alfred Stieglitz Collection (1987.250.1),
bequest of Georgia O'Keeffe.

Plate 25. *Flower Abstraction*.
1924, oil on canvas, 48 x 30 in.
Whitney Museum of American Art, New York (85.47),
50th anniversary gift of Sandra Payson.

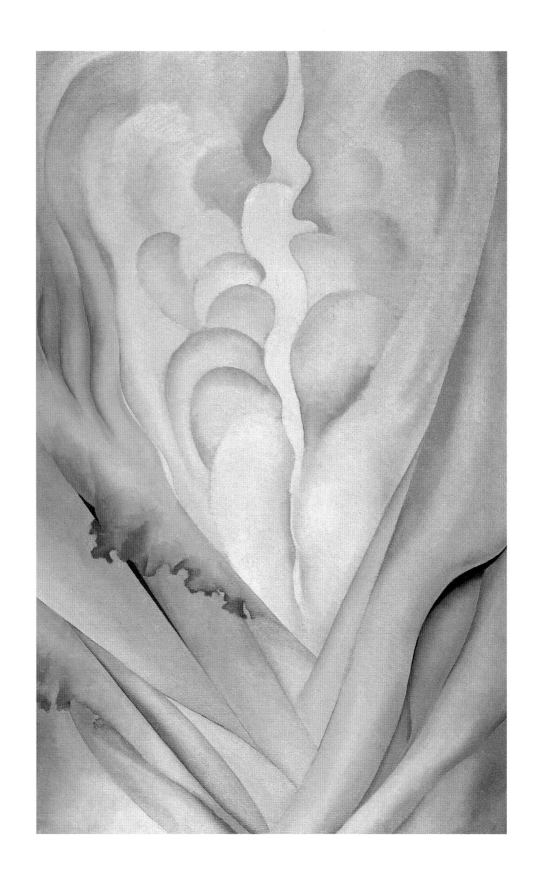

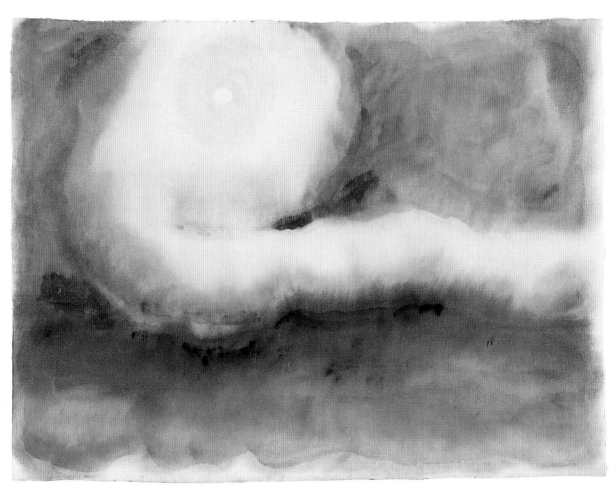

Plate 26. *Evening Star*.
1916, watercolor, 13 3/8 x 17 3/4 in.
Yale University Art Gallery, New Haven (1978.4),
The John Hill Morgan (B.A. 1983) Fund,
The Leonard C. Hanna, Jr. (B.A. 1913) Fund, and gifts of friends
in honor of Theodore E. Stebbins, Jr. (B.A. 1960).

opposite:

Plate 27. *Pelvis with Moon*.
1943, oil on canvas, 30 x 24 in.
Norton Museum of Art, West Palm Beach (58.29).

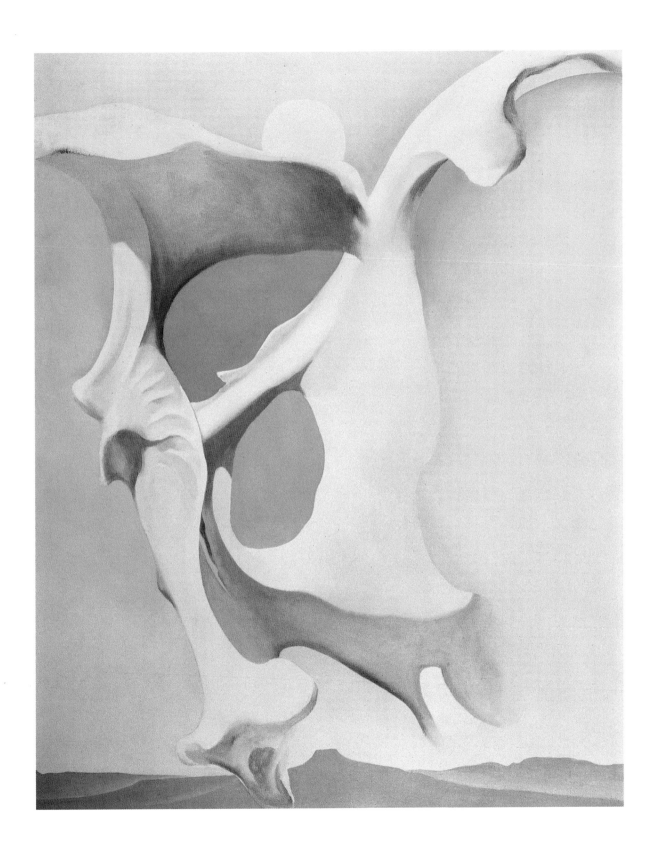

Plate 28. *Pelvis with Pedernal.*
1943, oil on canvas, 16 x 22 in.
Munson-Williams-Proctor Institute
Museum of Art, Utica, New York (50.19),
museum purchase.

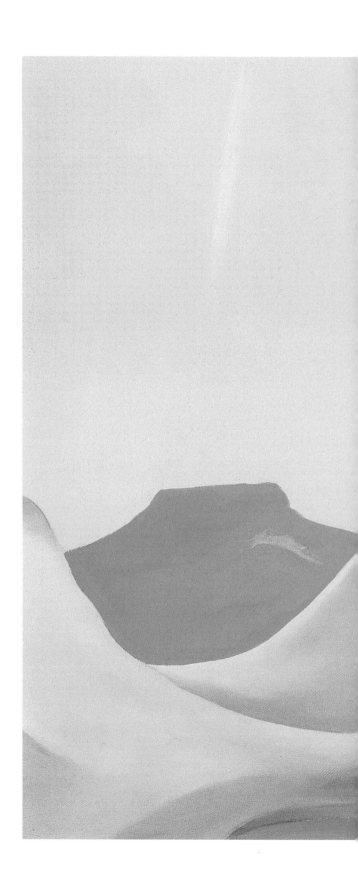

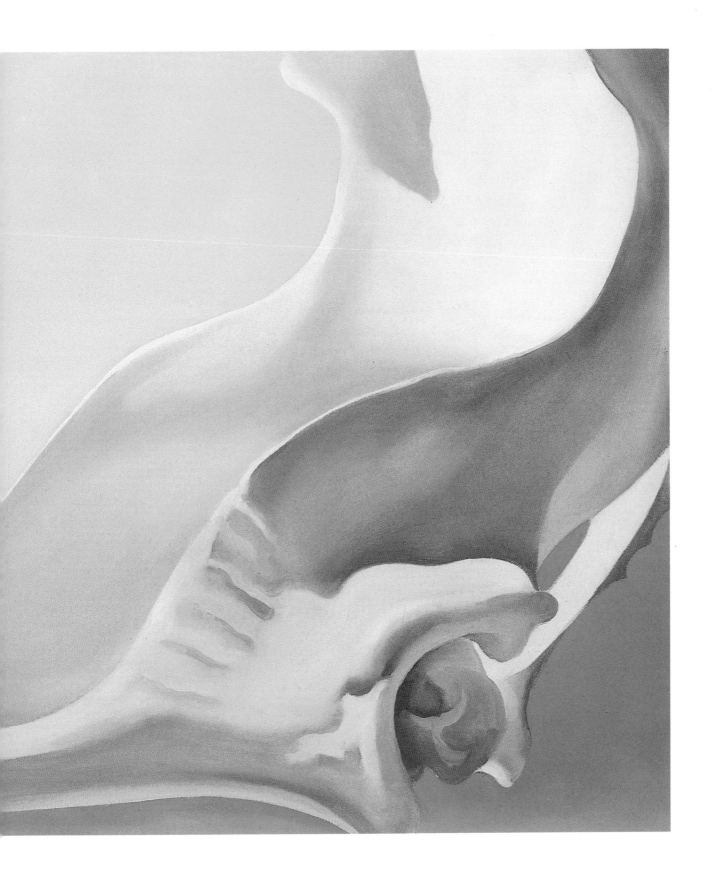

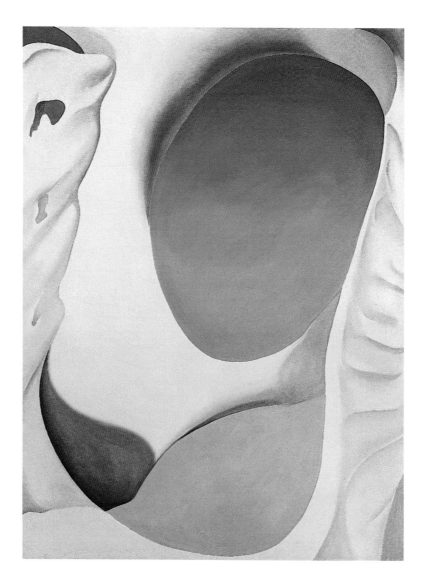

Plate 29. *Pelvis II*.
1944, oil on canvas, 40 x 30 in.
The Metropolitan Museum of Art, New York (47.19),
George A. Hearn Fund, 1947.

opposite:

Plate 30. *A Celebration*.
1924, oil on canvas, 35 $^1/_{16}$ x 18 $^1/_8$ in.
Seattle Art Museum, Washington (94.89),
gift of The Georgia O'Keeffe Foundation.

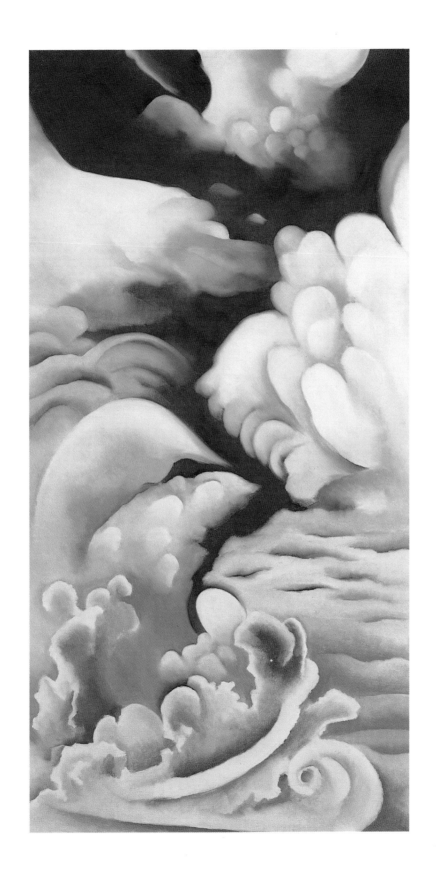

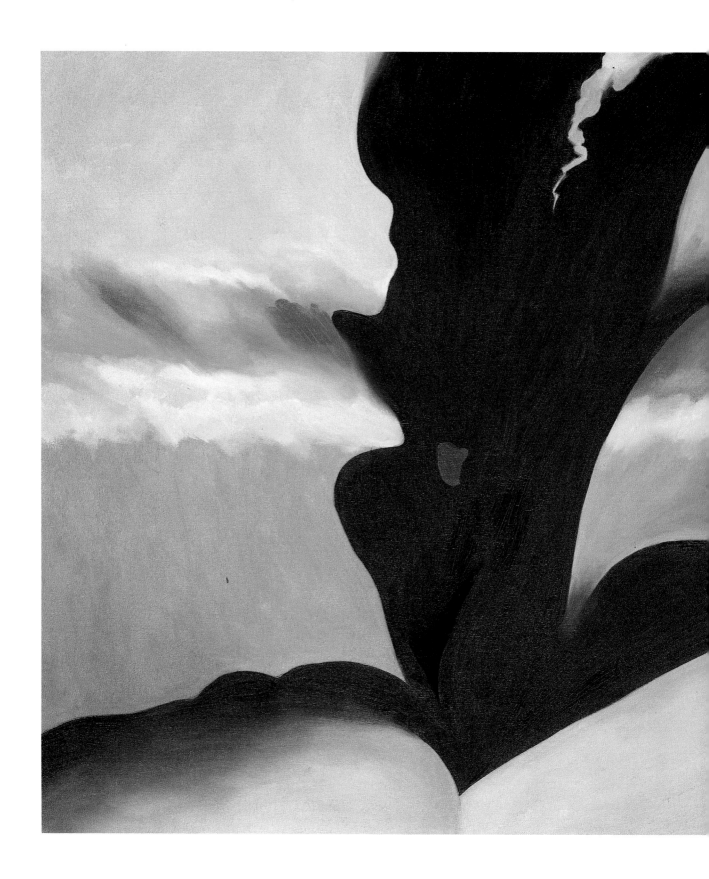

Plate 31. *Black Place Green*.
1949, oil on canvas, 38 x 48 in.
Whitney Museum of American Art,
New York (P.17.79),
promised 50th anniversary
gift of Mr. and Mrs. Richard D. Lombard.

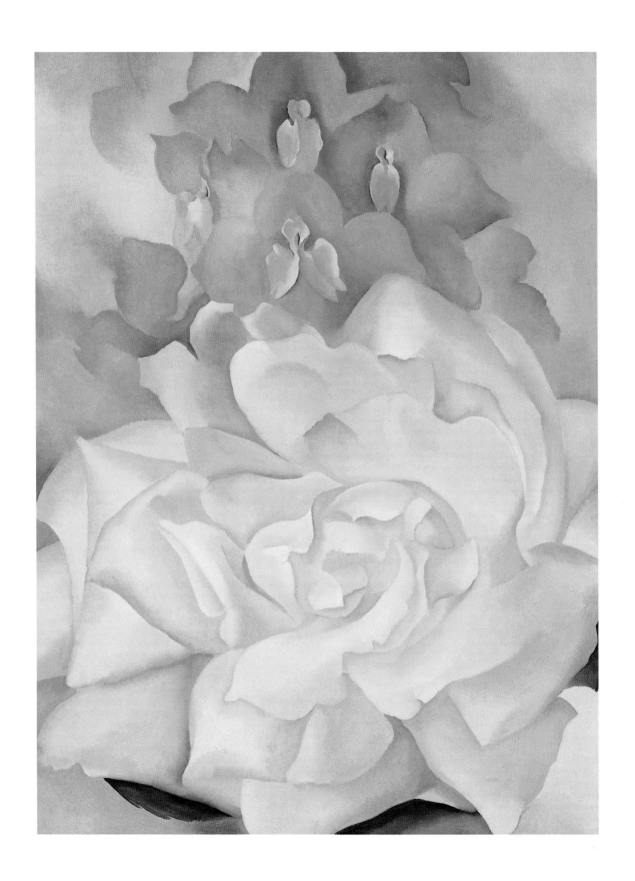

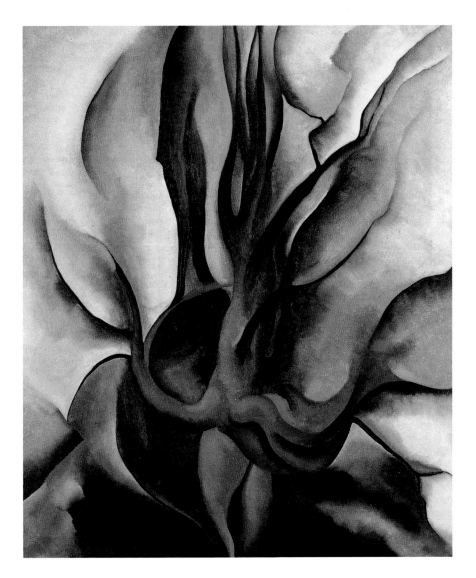

Plate 33. *Autumn Trees–The Maple.*
1924, oil on canvas, 36 x 30 in.
© The Georgia O'Keeffe Museum, Santa Fe (1996-3-1-2),
gift of The Burnett Foundation and Gerald and Kathleen Peters.

opposite:

Plate 32. *White Rose with Larkspur No. 2.*
1927, oil on canvas, 40 x 30 in.
Museum of Fine Arts, Boston (1980.207),
Henry H. and Zoë Oliver Sherman Fund.

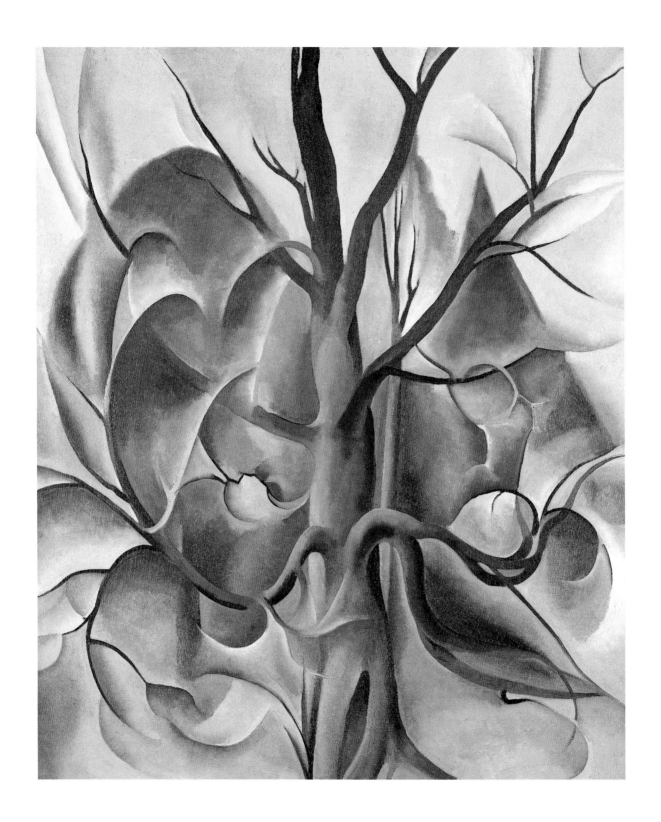

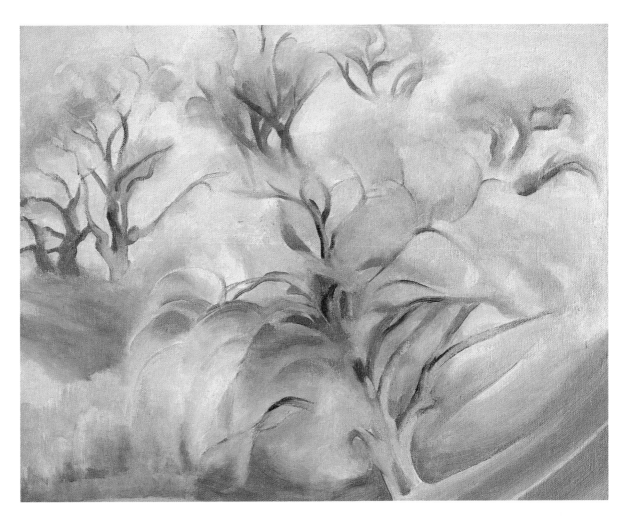

Plate 35. *Gray Tree by the Road*.
1952, oil on canvas, 16 x 20 in.
Corcoran Gallery of Art, Washington, D.C. (1984.20),
gift of Mrs. Bernhard G. Bechhoefer.

opposite:

Plate 34. *Gray Tree–Lake George*.
1925, oil on canvas, 36 x 30 in.
The Metropolitan Museum of Art, New York,
Alfred Stieglitz Collection (1987.377.2),
bequest of Georgia O'Keeffe, 1986.

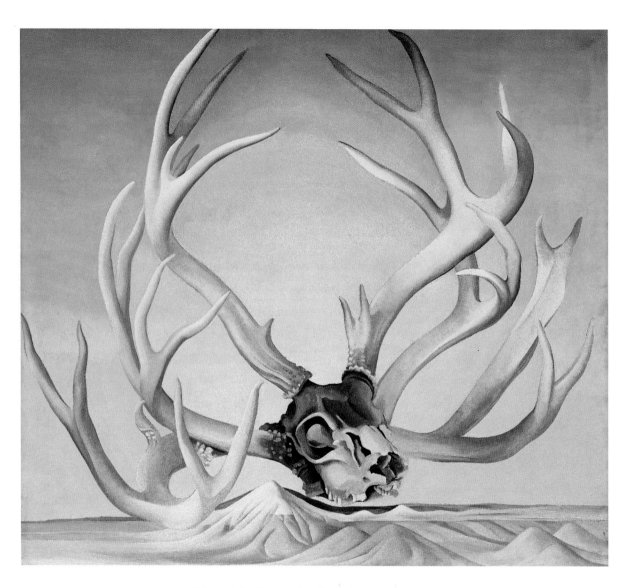

Plate 36. *From the Far Away Nearby.*
1937, oil on canvas, 36 x 40 ¹⁄₈ in.
The Metropolitan Museum of Art, New York,
Alfred Stieglitz Collection (59.204.2), 1959.

opposite:

Plate 37. *Like an Early Blue Abstraction.*
1977, watercolor on paper, 30 x 22 in.
Collection of Gina Puluozzi.

Selected Bibliography

Agee, William C. *Synchronism and Color Principles in American Painting, 1910–1930*. New York: M. Knoedler & Co., 1965.

Arrowsmith, Alexandra, and Thomas West, eds. *Two Lives, Georgia O'Keeffe & Alfred Stieglitz: A Conversation in Paintings and Photographs*. New York: Harper Collins, 1992.

Ashton, Dore. *A Reading of Modern Art*. rev. ed. New York: Harper and Row, 1971.

Baer, Nancy Van Norman, ed. *The Art of Enchantment: Diaghilev's Ballets Russes, 1909–1929*. San Francisco: Fine Arts Museums, 1988.

Bergson, Henri. *Creative Evolution*. Translated by Arthur Mitchell. New York: Modern Library, 1944.

Bry, Doris, and Nicholas Callaway, eds. *Georgia O'Keeffe: The New York Years*. New York: Alfred A. Knopf, 1991.

Camfield, William A. *Francis Picabia: His Art, Life, and Times*. Princeton: Princeton University Press, 1979.

Clair, Jean. *Symbolist Europe—Lost Paradise*. Montreal: Musée des Beaux Arts, 1995.

Copeland, Roger, and Marshall Cohen, eds. *What is Dance? Readings in Theory and Criticism*. New York: Oxford University Press, 1983.

Cowart, Jack, and Juan Hamilton. *Georgia O'Keeffe: Arts and Letters*. Washington, D.C.: National Gallery of Art, 1987.

Crunden, Robert M. *American Salons: Encounters with European Modernism, 1885–1917*. New York: Oxford University Press, 1993.

Davidson, Abraham A. *Early American Modernist Painting, 1910–1935*. New York: Harper and Row, 1981.

Dell, Floyd. *Women as World Builders, Studies in Modern Feminism*. Chicago: Forbes and Co., 1913.

de Zayas, Marius. *African Negro Art: Its Influences on Modern Art*. New York: Modern Gallery, 1916.

Dow, Arthur Wesley. *Composition: A Series of Exercises in Art Structure for the Use of Students and Teachers*. New York: Doubleday-Doran & Co., 1912.

Dow, Arthur Wesley. *Theory and Practice of Teaching Art*. 2nd ed. New York: Teachers College, Columbia University Press, 1912.

Eddy, Arthur Jerome. *Cubists and Post-Impressionism*. Chicago: A. C. McClurg & Co., 1914.

Eisler, Benita. *O'Keeffe and Stieglitz: An American Romance*. New York: Doubleday, 1991.

Eldredge, Charles C. *Georgia O'Keeffe: American and Modern*. New Haven: Yale University Press, 1993.

Franko, Mark. *Dancing Modernism/Performing Politics*. Bloomington and Indianapolis: Indiana University Press, 1995.

Goldwater, Robert J. *Symbolism*. New York: Harper and Row, 1979.

Green, Jonathan, ed. *Camera Work: A Critical Anthology*. New York: Aperture, 1973.

Greenough, Sarah, and Juan Hamilton. *Alfred Stieglitz, Photographs and Writings*. Washington, D.C.: National Gallery of Art, 1983.

Hartley, Marsden. *Adventures in the Arts, Informal Chapters on Painters, Vaudeville and Poets*. New York: Boni and Liveright, 1921.

Hayes, Jeffrey. "Oscar Bluemner's Late Landscapes: 'The Musical Color of Fateful Experience.'" *Art Journal* (Winter 1984): 352–60.

Henderson, Linda Dalrymple. "Mabel Dodge, Gertrude Stein, and Max Weber: A Four Dimensional Trio." *Arts Magazine* 57 (September 1982): 106–11.

Hoffman, Katherine. *An Enduring Spirit: The Art of Georgia O'Keeffe*. Metuchen, N.J., and London: Scarecrow Press, 1984.

Kandinsky, Wassily. *Concerning the Spiritual in Art*. Translated by M. T. H. Sadler. New York: Dover Publications, 1977.

Kendall, Elizabeth. *Where She Danced, The Birth of American Art—Dance*. Berkeley: University of California Press, 1979.

Lehmann, Andrew G. *The Symbolist Aesthetic in France, 1885–1895*. Oxford: Basil Blackwell, 1950.

Levin, Gail. *Synchromism and American Color Abstraction, 1916–1925*. New York: George Braziller, 1978.

Lynes, Barbara Buhler. *O'Keeffe, Stieglitz and the Critics, 1916–1929*. Chicago: University of Chicago Press, 1989.

Nietzsche, Friedrich Wilhelm. *The Portable Nietzsche*. Edited and translated by Walter Kaufmann. New York: Viking Press, 1968.

Patten, Christine Taylor. *O'Keeffe at Abiquiu*. With photographs by Myron Wood. New York: Harry N. Abrams, 1995.

Peters, Sarah Whitaker. *Becoming O'Keeffe: The Early Years*. New York: Abbeville, 1991.

Risatti, Howard. "Music and the Development of Abstraction in America: The Decade Surrounding the Armory Show." *Art Journal* 39 (Fall 1979): 8–13.

Robinson, Roxanna. *Georgia O'Keeffe: A Life*. New York: Harper and Row, 1989.

Sorell, Walter. *Dance in Its Times.* New York: Doubleday, 1981.

Vigier, Rachel. *Gestures of Genius: Women, Dance, and the Body.* Stratford, Ontario: The Mercury Press, 1994.

Walkowitz, Abraham. *Isadora Duncan in Her Dances.* Girard, Kansas: Haldeman-Julius Publications, 1945.

Wright, Willard Huntington. *The Creative Will, Studies in the Philosophy and the Syntax of Aesthetics.* New York: John Lane Co., 1916.

Zilczer, Judith. "Synaesthesia and Popular Culture: Arthur Dove, George Gershwin, and the 'Rhapsody in Blue.'" *Art Journal* (Winter 1984): 361–66.

List of Plates and Photograph Credits

listed in order of appearance

Georgia O'Keeffe at the San Francisco Museum
of Modern Art with her sculptural piece
Abstraction, page 53, fig. 19, photograph by
Ben Blackwell

Dancing Trees, Alfred Stieglitz, page 55, fig. 20,
Museum of Fine Arts, Boston

PLATES

Blue No. 1, page 65, pl. 1, The Brooklyn Museum
of Art, New York

Blue No. 2, page 66, pl. 2, The Brooklyn Museum
of Art, New York

Blue No. 3, page 67, pl. 3, The Brooklyn Museum
of Art, New York

Blue No. 4, page 69, pl. 4, The Brooklyn Museum
of Art, New York

Music–Pink and Blue No. 1, page 70, pl. 5,
collection of Mr. and Mrs. Barney A. Ebsworth

Music–Pink and Blue No. 2, page 71, pl. 6,
Whitney Museum of American Art, New
York, photograph by Geoffrey Clements

Blue Nude, page 73, pl. 7, Sheldon Memorial Art
Gallery, University of Nebraska-Lincoln

Nude Series (Seated Red), page 74, pl. 8,
The Georgia O'Keeffe Museum, Santa Fe,
photograph by Malcolm Varon, New York
City, © 1997

Nude Series I, page 75, pl. 9, copyright 1989
The Georgia O'Keeffe Foundation, photograph
by Malcolm Varon, New York City, © 1997

Nude Series II, page 77, pl. 10, copyright 1989
The Georgia O'Keeffe Foundation, photograph
by Malcolm Varon, New York City, © 1997

Nude Series III, page 78, pl. 11, National Gallery
of Art, Washington, D.C., photograph by Lee
Ewing

Nude Series IV, page 79, pl. 12, private collection

Nude Series VI, page 81, pl. 13, copyright 1989
The Georgia O'Keeffe Foundation, photograph
by Malcolm Varon, New York City, © 1997

Nude Series VII, page 82, pl. 14, The Georgia
O'Keeffe Museum, Santa Fe, photograph by
Malcolm Varon, New York City, © 1997

Nude Series VIII, page 83, pl. 15, The Georgia
O'Keeffe Museum, Santa Fe, photograph by
Malcolm Varon, New York City, © 1997

Nude Series IX, page 85, pl. 16, copyright 1989
The Georgia O'Keeffe Foundation, photograph
by Malcolm Varon, New York City, © 1997

Seated Nude X, page 87, pl. 17, The Metropolitan
Museum of Art, New York

Seated Nude XI, page 88, pl. 18, The Metropolitan
Museum of Art, New York

Nude Series XII, page 89, pl. 19, The Georgia
O'Keeffe Museum, Santa Fe, photograph by
Malcolm Varon, New York City, © 1997

Pink and Green Mountains No. 1, page 90,
pl. 20, Spencer Museum of Art, The University
of Kansas